MARTIN MUNKACSI

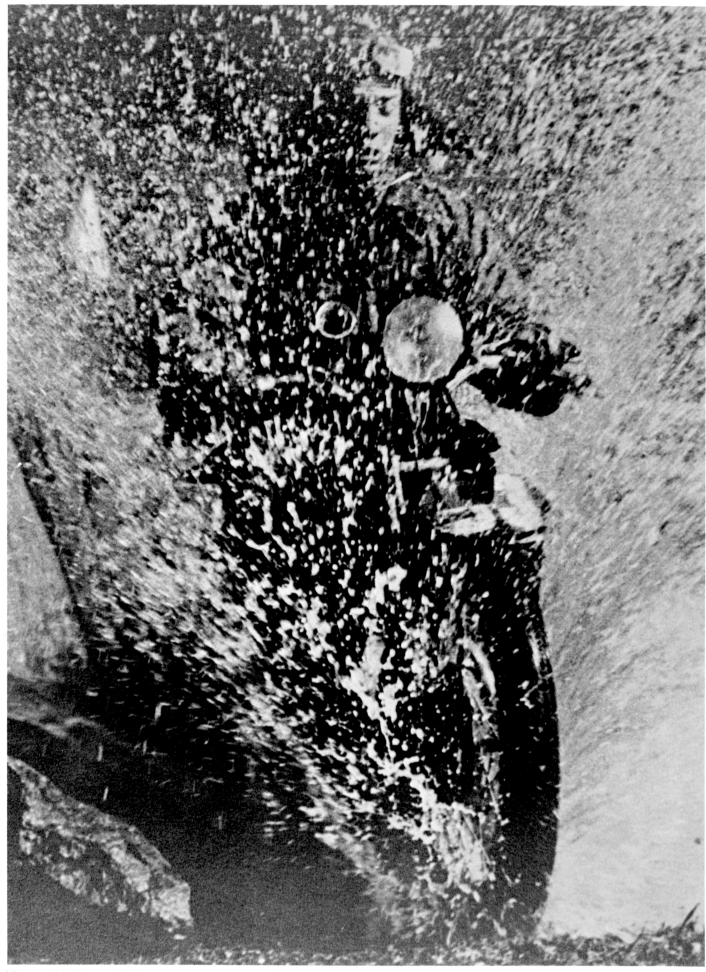

Motorcyclist, Europe, 1920s

MARTIN MUNKACSI

BIOGRAPHICAL PROFILE BY

SUSAN MORGAN

AN APERTURE MONOGRAPH

EUROPE: THE ART OF SPONTANEITY

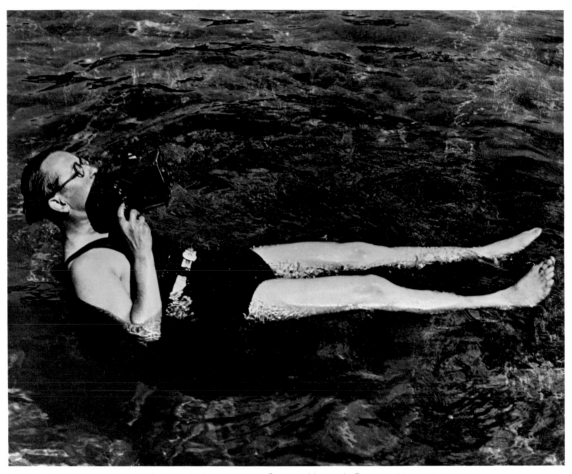

Munkacsi himself, shooting fashion in Long Island Sound, *Harper's Bazaar*, November 1935

In Martin Munkacsi's dynamic photographs, people speed through modern life. Racing against time, their high-spirited images are caught and fixed to an instant. Munkacsi pictured human experience as vigorous improvisation, a kinetic series of unexpected leaps set to a distinctly twentieth-century tempo. His career thrived in the years between the wars; faced with a rapidly changing world, Munkacsi was able to display, in both his work and his life, a remarkable sophistication and a quick-witted flair for innovation.

Martin Munkacsi was born on May 18, 1896, in Kolozsvár, Hungary, the historic capital of Transylvania (now Cluj Napoca, Romania). The family name had been changed by his father from either Mermelstein or Marmorstein to Munkacsi. The new name, chosen for the local city of Munkács, was distinctly Hungarian and not identifiably Jewish. In 1896 the Hungarian government, led by Kalman Tisza's Liberal Party, had publicly denounced anti-Semitism and legislated the emancipation of Jews; but anti-Semitism, in an era still marked by pogroms, was clearly a part of daily life for the Hungarian Jewish minority,

which made up only 5 percent of the country's population.

Munkacsi was the fourth child, the middle among seven, born to a working-class family. His father was a housepainter, notorious not only as the town drunk, but celebrated as the village magician who could perform Houdini-esque escapes from burning, padlocked shipping crates. Munkacsi told colorful tales of his Transylvanian childhood, but as his daughter Joan Munkacsi once pointed out, "My father never let the truth get in the way of a good story, so attempting to pin down the details of his life becomes, ultimately, an exercise in divination."

In 1902 Munkacsi's family moved to Dicsö-Szent-Marton, a town famous for a rather eccentric practice: mental patients were commonly lodged with local families. Munkacsi was a nimble, playful child. He built his own ice skates and went fearlessly sledding in the nearby mountains; he was a natural athlete who excelled at soccer. (His daughter recalls that he had always been a soccer player and that, even at age sixty, "he would never simply throw a piece of paper in a waste basket. He would toss it first in the air, butt it with his head,

bounce it off his elbow, and kick it backward with his foot into the basket.")

Endlessly curious, Munkacsi grew restless in a large family and the confining atmosphere of small-town life. He ended his formal education at age eleven and began to run away from home on a regular basis. Like Imre, the boy hero in his 1945 autobiographical novel, *Fool's Apprentice*, Munkacsi often "stole quietly out to the street and set out briskly for nowhere in particular."[1] At sixteen he left home for good and went to live in Budapest. Munkacsi was scarcely alone in beginning his adult life as an émigré; all across rural Hungary people were abandoning the collapsing economies of the farm communities. The skilled labor force (with a remarkable literacy rate of 80 percent) was moving to the cities. In Budapest nearly one-quarter of the population was now made up of middle-class Jews. Munkacsi arrived there with the adolescent hope of becoming a poet and the promise of a job as an apprentice housepainter.

After a year in Budapest Munkacsi abandoned his job as housepainter and went to work for the local press. He wrote for *Az Est*, the sports daily, reporting on soccer matches and automobile races. Proving himself to be a lively observer of the city, Munkacsi was soon contributing interviews and gossip to the weekly newspapers, *Pesti Napló* and *Színházi Élet*. He was even able to sell his poetry to the small literary magazines. Munkacsi's ambitions in Budapest seem to have been realized with considerable ease; he was only eighteen and publishing regularly as a writer.

Despite the difficulties of life in Hungary during World War I, Munkacsi remained in Budapest and began to publish photographs in *Az Est* and *Theatre Life*, a weekly review. He was a self-taught photographer and his first camera was homemade. He looked at the city with a genuinely inquisitive eye; he constantly climbed up ladders and scrambled on walls to find an original view. By adding a fake lens to his camera, he could appear to be photographing in one direction while he surreptitiously shot in another, sneaking up on his subjects and catching images charged with surprise. His natural métier was as a sports photographer, tapping into the exhilaration and adrenalin rush of the event and articulating it with high-velocity urgency. Munkacsi often rode in motorcycle races, and he even strapped himself to the side of a speeding racecar to experience the excitement and translate the sensation to his pictures.

In 1923, Munkacsi took the photograph that catapulted his career to new heights. Sent out of town by *Az Est* to cover a soccer match, he left the city by tram and busily snapped the passing street scenes with his newly purchased camera. When he returned to Budapest a week later, he found the local news focused on the arrest of an old man accused of murdering one of the Kaiser's soldiers. Munkacsi realized that he had unwittingly photographed that fatal chance encounter from the trolley window. When his film was developed, Munkacsi had clear photographic proof that the soldier had provoked the old man.

In some versions of this story, Munkacsi's candid shot revealed the soldier's brandished gun and the old man reaching for a knife in self-defense; in other versions, the photograph simply made obvious that it was the soldier, not the private citizen, who had instigated the fight. Munkacsi's photographs were introduced as court evidence. The old man's charge was reduced from murder to manslaughter, and overnight Munkacsi was promoted from sports photographer to photojournalist. In 1966, when Michelangelo Antonioni's film *Blow-Up* premiered, Munkacsi's ex-wife, Helen Munkacsi Sinclair, told his daughter Joan, "They stole your father's plot!"

Munkacsi's working relationship with *Az Est* continued until 1927, when he was commissioned to photograph the actress-wife of the magazine's publisher. The assignment was done on location at the couple's summer home in the countryside. When Munkacsi delivered the photographs and a record of his travel expenses, the publisher haggled over a few pennies and refused reimbursement. According to Munkacsi, he sent his publisher a note: "I have no desire to remain in a country where men have to cheat one another out of a few [cents]. . ." and left for Berlin the very next day.[2]

Over the years, Munkacsi revised and refined his anecdotes. He told his life story as if he were constructing a novel, transforming the murky transitions into clear, decisive turning points. In Hungary Munkacsi had been married to a dancer from the Budapest Operetta. Their marriage was said to have been fraught with jealousies and disagreements over their religious differences (his wife, a Roman Catholic, had promised to raise their children as Jews; Munkacsi discovered that their only son was secretly being trained as a Catholic). By 1927 his first marriage had ended in divorce and his relationship with *Az Est* had soured. He had arrived in the city as a romantic adolescent; at thirty-one his ambitions were far greater than what Budapest could offer. But Berlin was another story altogether.

"The old Berlin had been impressive," Peter Gay writes in his book *Weimar Culture: the Outsider as Insider*; "the new [1920s] Berlin was irresistible. To go to Berlin was the aspiration of the composer, the journalist, the actor; with its superb orchestras, its hundred and twenty newspapers, its forty theaters, Berlin was the place for the ambitious, the energetic, the talented. Wherever they started, it was Berlin that they became, and Berlin that made them famous. . . ."[3] And it was in Berlin, the "capital of exiles," as Nabokov described it, that Munkacsi became famous.

Berlin in 1927 was still "the city in which the outsider could make his home and extend his talents";[4] Munkacsi arrived and signed a three-year contract with Ullstein Verlag, the city's major publishing house. Vicki Baum, the author of *Grand Hotel*, remembered Ullstein as "one of the several hearts of the city," as well as "the focal point of liberalism" in Berlin.[5] In 1928 Munkacsi's first credited story appeared in the October 14th issue of *Berliner Illustrirte Zeitung*, Ullstein's weekly picture magazine. The direct forerunner of *Life* magazine, the *Berliner*

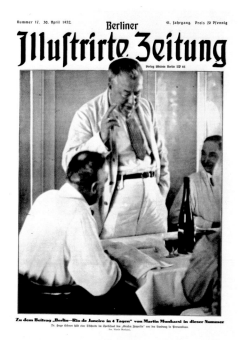

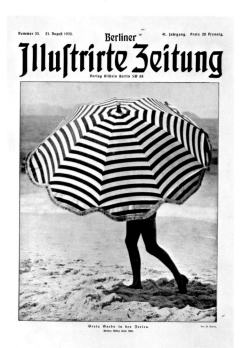

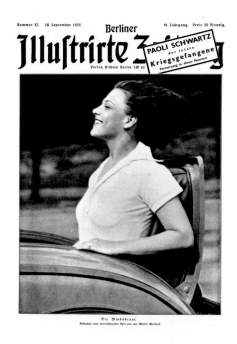

Illustrirte was the most widely read magazine of its kind in the world; its circulation was reported at two million. A Munkacsi photograph appeared on the magazine's cover for the first time in November 1928. He photographed for the other Ullstein publications: *Die Dame*, the German equivalent of *Vogue*, and *Uhu*, a pocket-sized, rather arty monthly journal for "middle-brow tastes"[6] that featured essays and photographs of nudes. He also did occasional work for Ullstein's competitors, *Die Woche* and *The Studio*. In 1929 he contributed to *Knipsen*, an Ullstein book for amateur photographers.

One of Munkacsi's photographs from 1929 shows a grassy hillside covered with dozens of pale, sunbathing children. The image, identified as "Summer Camp, near Bad-Kissingen, Germany,"[7] is startling and disturbing. The bodies scattered about at odd angles resemble the aftermath scene on a battlefield; an overlay of parallel power lines creates a curious pattern like a musical staff on which the small bodies appear as notes. The children are reduced to visual geometry, all sharp elbows and pointy knees, like shards of glass reconfiguring in a kaleidoscope. Looking back at this image, Munkacsi wrote, "I do not regard this as my finest photograph, yet I like it best. Its contents are most dramatic. It depicts the hopeless fate of human beings: their similarity to the fate of herrings pressed into a barrel, or pressed in a city, minus air, with no horizon—freedom on paper only, and not in fact—with duties made by themselves or imposed by leaders, to hold them in a certain spot in a certain manner. I like it because it saddens me again and again, whenever I look at it."[8]

Working for Ullstein, Munkacsi traveled throughout Europe,

as well as to Africa and South America. Visiting Liberia in about 1930, he photographed three boys running into the surf. This horizonless image, an exuberant silhouette against the white froth of sea spray, revels with delight. Henri Cartier-Bresson remembered first seeing the photograph in 1931 or 1932: "I must say that it is that very photograph which was for me the spark that set fire to the fireworks . . . and made me suddenly realize that photography could reach eternity through the moment."[9]

Munkacsi claimed, rather characteristically, to be the highest-paid photographer in Berlin; it was a lively, but somewhat disputable, boast. He was obviously an enthusiast who viewed the world with great excitement and pleasure. Working for Ullstein, he thrived, photographing everything from horse markets to the lightning effects of high-voltage electricity. Quick to incorporate bird's-eye views, Munkacsi encountered new situations from even newer vantage points: he photographed from the heights of the *Graf Zeppelin*—the gas-propelled airship, predecessor to the ill-fated *Hindenburg*—en route to Brazil (a trip that took well over one hundred hours).

Munkacsi advised would-be photographers to "pick unexpected angles. Lie down on your back,"[10] and his work introduced an intuitive take on the recent New Photography,

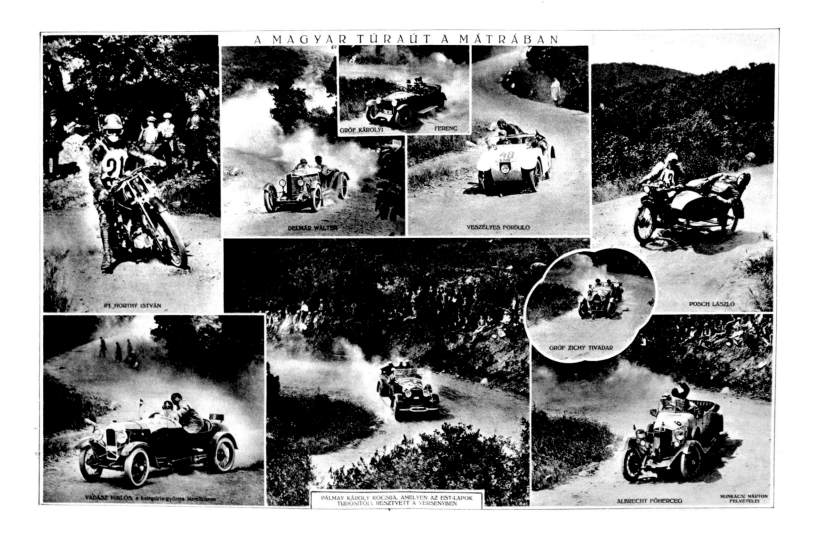

A MAGYAR TÚRAÚT A MÁTRÁBAN

Auto and motorcycle racing montage, *Berliner Illustrirte Zeitung*, *Pesti Napló*, 1927

with its concern for dramatic angles, strong diagonals and bold patterns.[11] His covers for the *Berliner Illustrirte Zeitung* were memorable: there is a photograph of the elusive Greta Garbo on holiday with only her legs visible from beneath an enormous striped beach umbrella; an unidentified woman, "the wind's fiancée," glanced "from a passing car," racing by with her head thrown back in heedless laughter as she sits snugly in an open rumble seat; and a curiously tight close-up of a sunburned skier, Leni Riefenstahl—a young actress in the popular German "mountain films" who would go on to become famous as director of the documentaries *Victory of Faith* and *Triumph of the Will*, commissioned by Adolf Hitler.

On February 28, 1933, Nazi Party Propaganda Minister Joseph Goebbels implemented his scheme to burn the Berlin Reichstag; the next day, Hitler's dictatorship began with a decree that eliminated constitutional protection of political, personal, and property rights. During 1933 Munkacsi was sent on assignment to England and the United States. He worked in London and Birmingham, New York and San Francisco, but he returned to Berlin and remained there for another year. By 1934 the Ullstein Verlag had attempted to adjust to anti-Semitic pressure by firing Jewish employees and hiring Nazi editors.[12] Munkacsi received an assignment to photograph fruit for one of Ullstein's women's magazines. He delivered twenty prints, of which five were immediately rejected by the new editor. "These are bananas," was the explanation. "Bananas are not an Aryan fruit!"

In one of Munkacsi's last Berlin photographs, "Having fun at Breakfast," a man dances straight up a wall as he drinks his morning coffee. It is an exceptional image for Munkacsi: one of his typical high-spirited subjects is trapped in an enclosed space, caught in the unexpected act of climbing the walls.

Munkacsi soon left Germany for the United States: he traveled by boat and arrived at New York on his thirty-eighth birthday, May 18, 1934. "If Berlin tasted of the future, the taste of Berlin was cruelly mistaken: there was little future left. Life would not leave art alone."[13]

continued on page 46

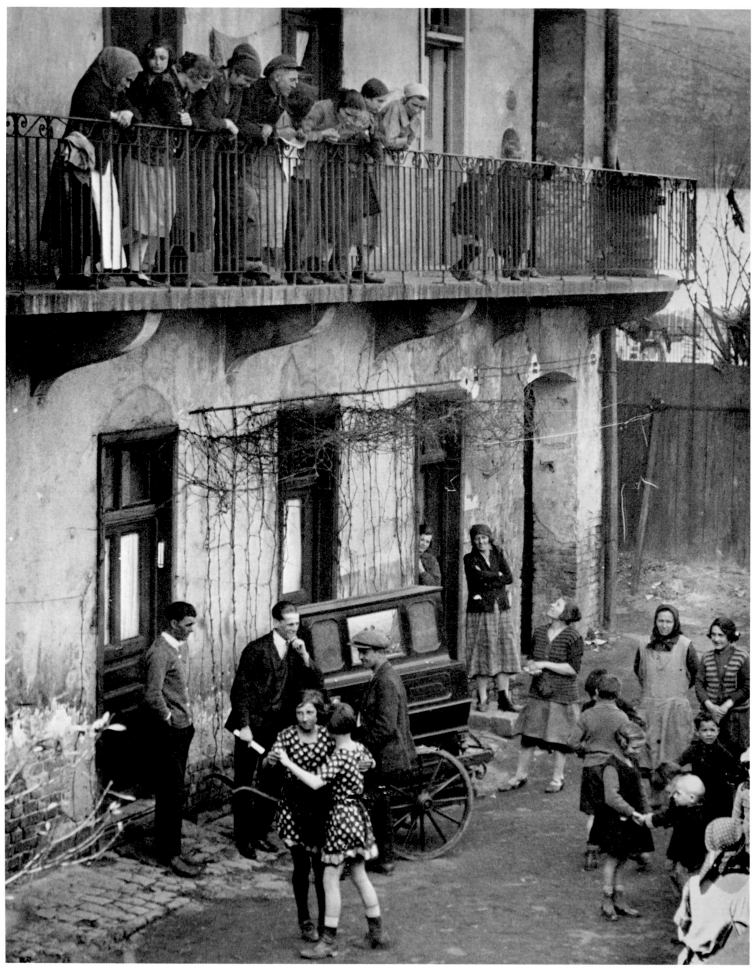

"Girls Dancing in the Streets," Budapest, c. 1923

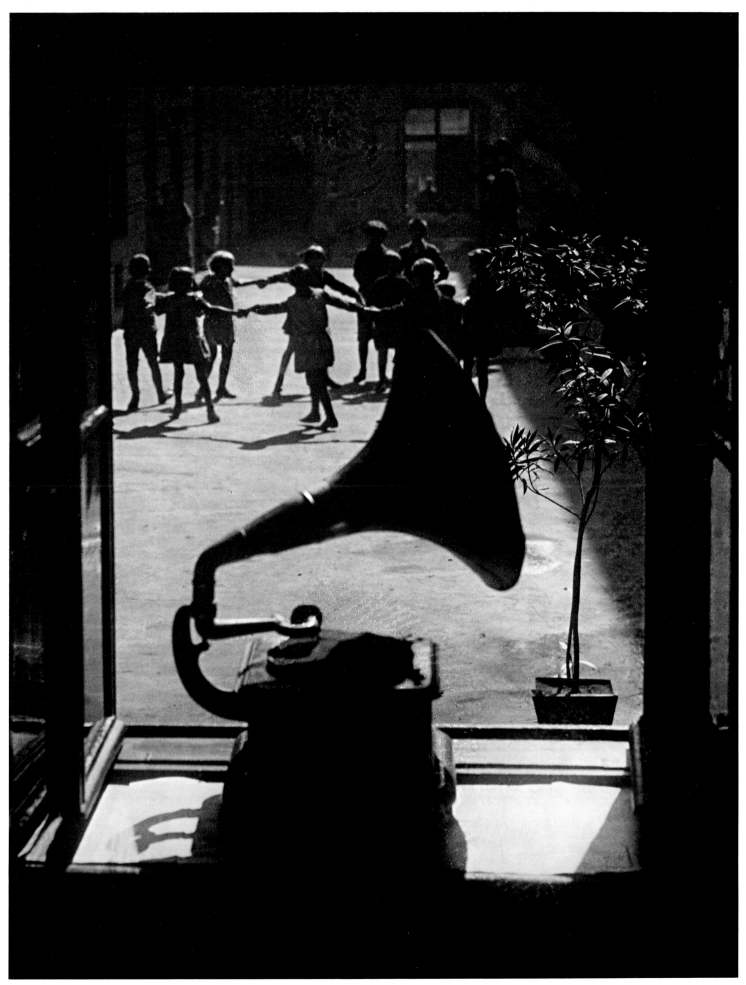

"The Rent-Barracks," *Pesti Napló*, Budapest, c. 1923

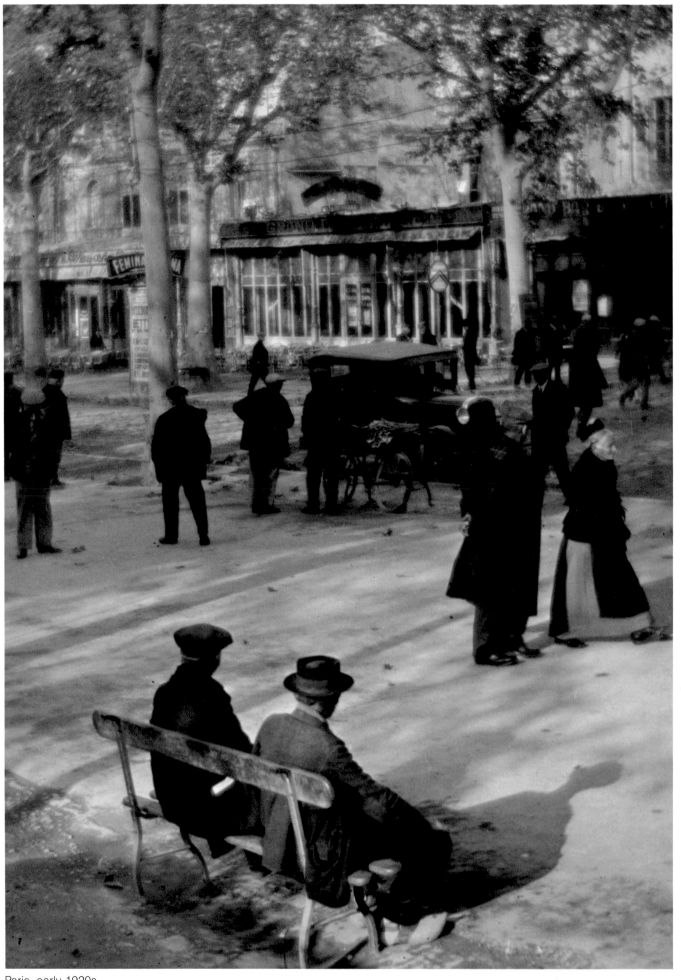

Paris, early 1920s

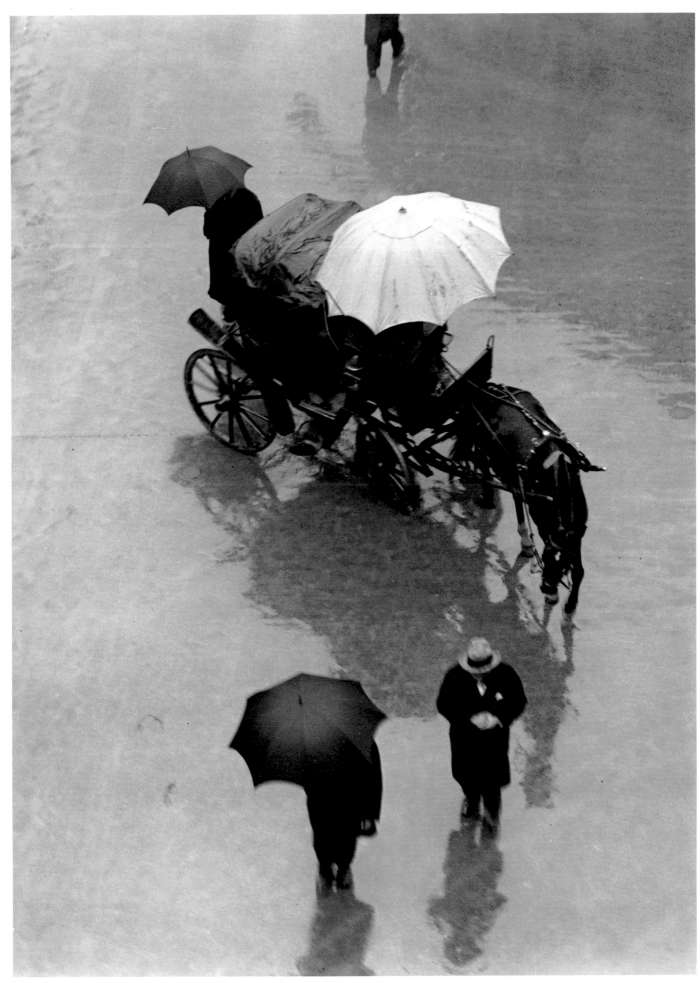

Palermo, Sicily, 1927

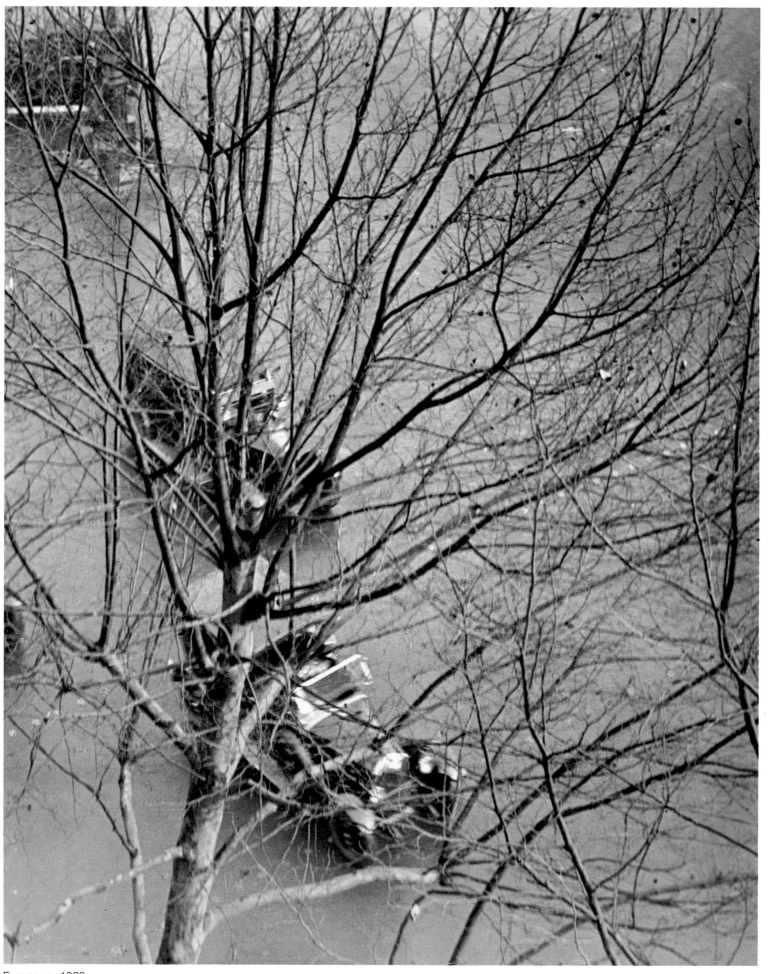

Europe, c. 1929

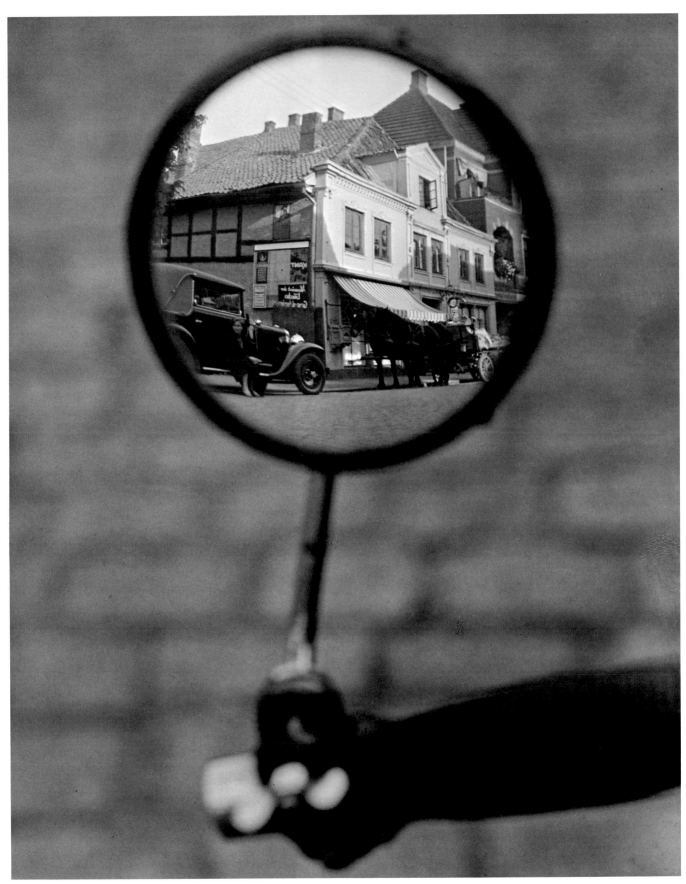

Reflection in a motorcycle mirror, Berlin, c. 1929

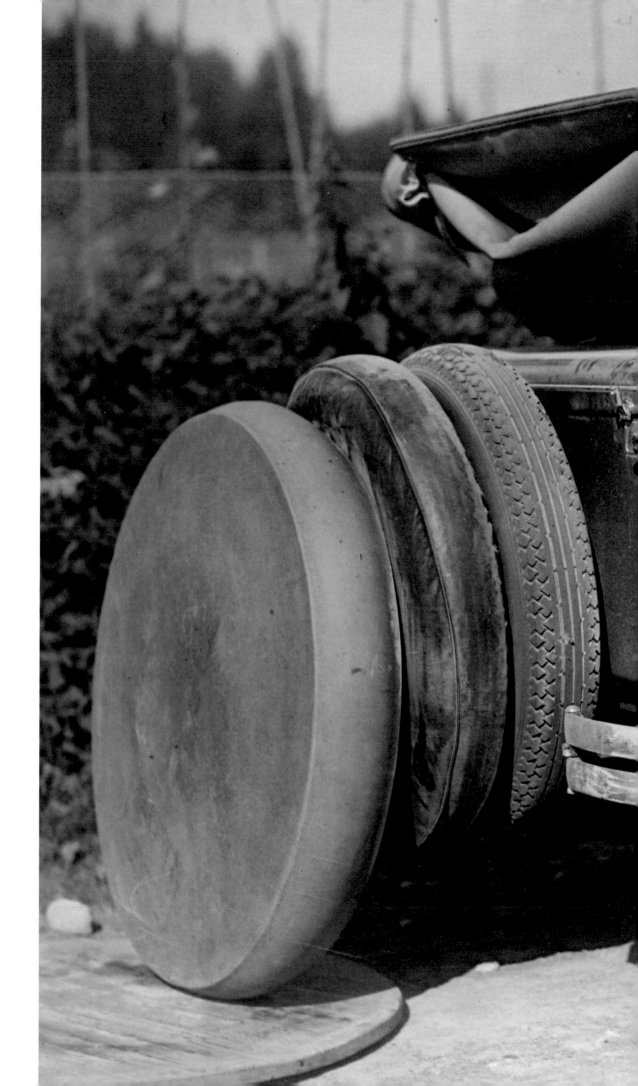

"Ein Merkwürdiges Reserverad
(A Strange Spare Tire),"
Holland, 1929

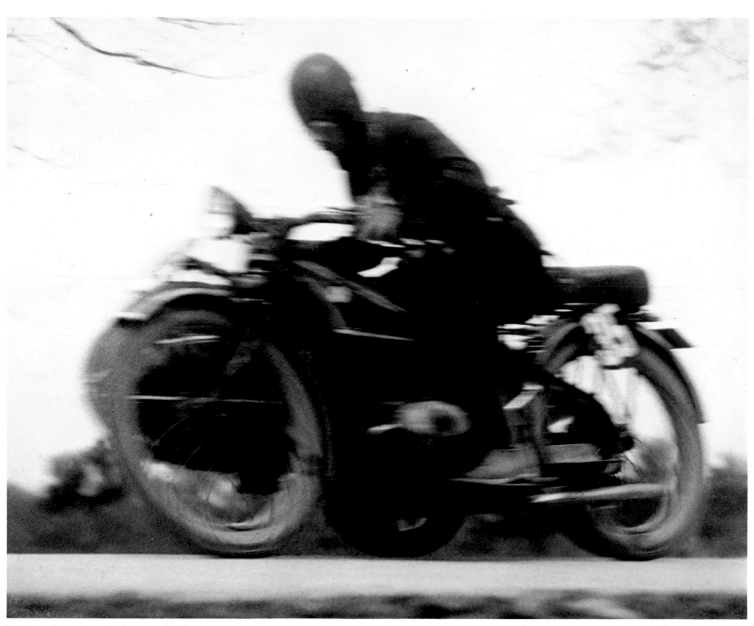

Motorcycle racing, Europe, c. 1929

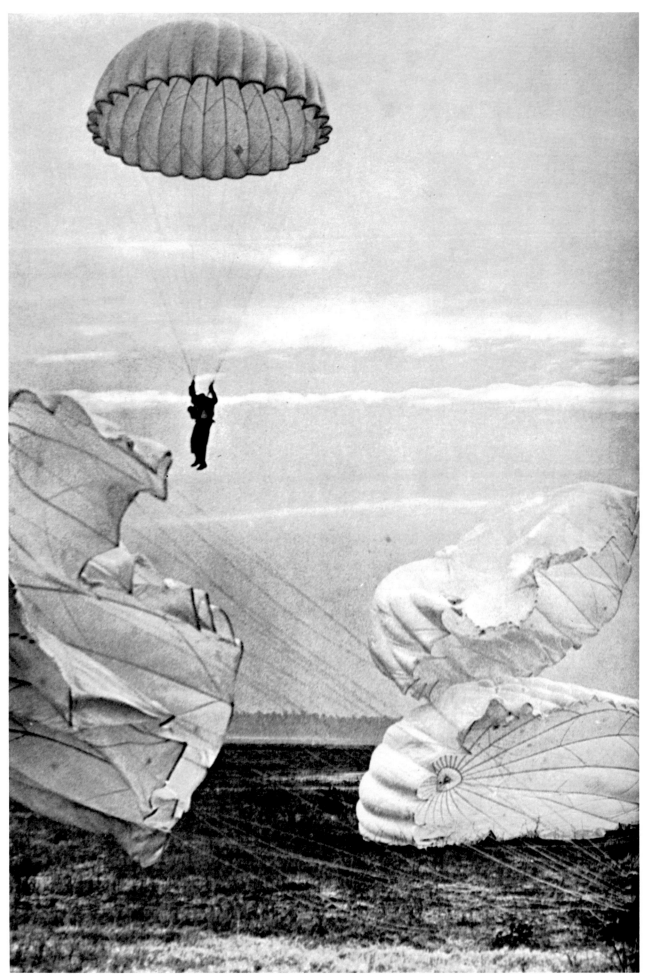

Skydivers, United States, c. 1935–45

Car racing,
Europe, c. 1929

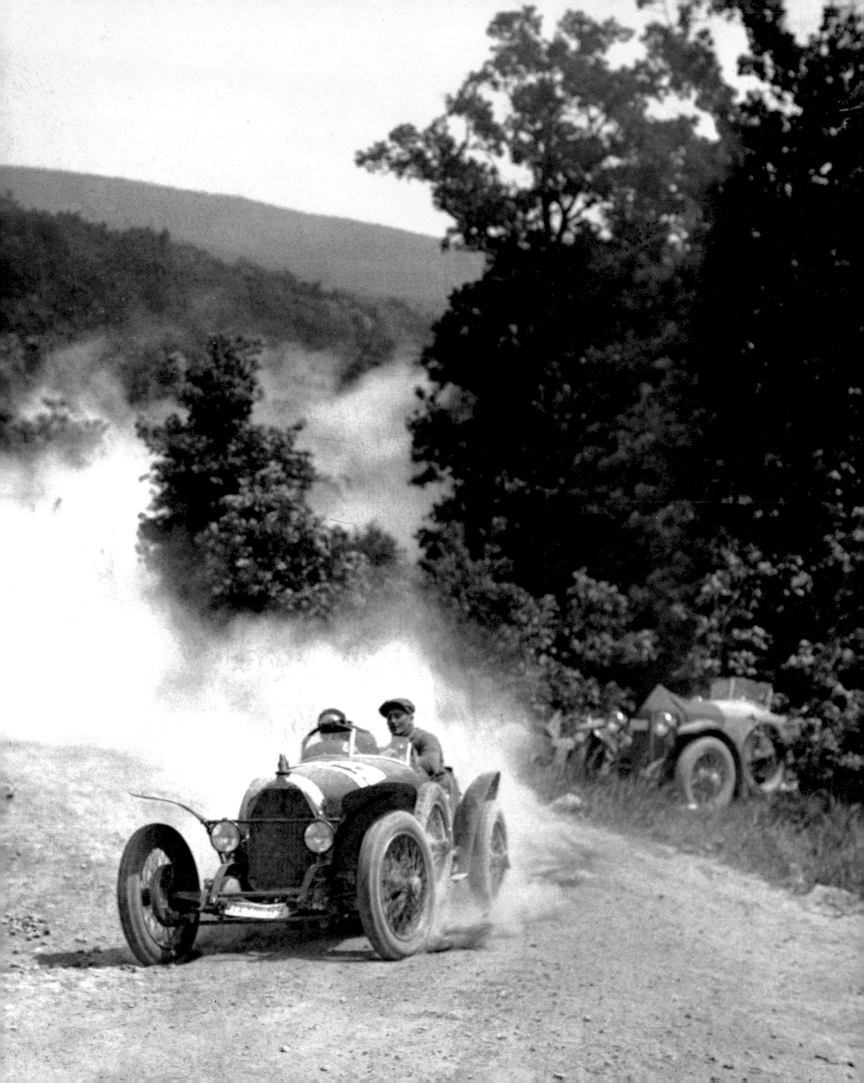

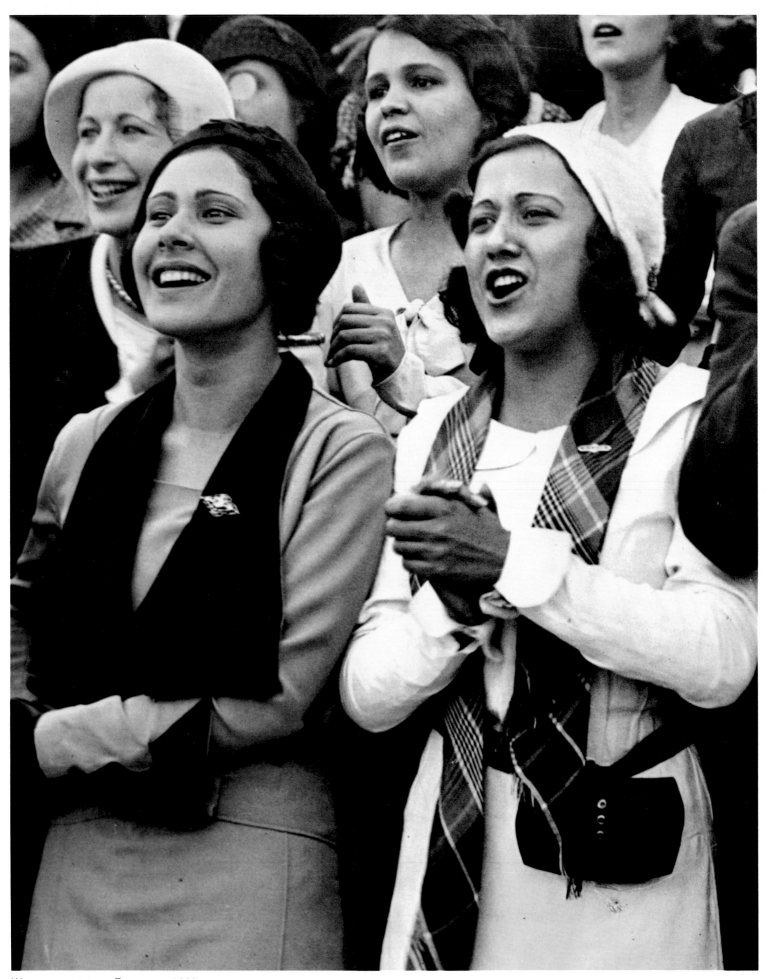

Women spectators, Europe, c. 1928

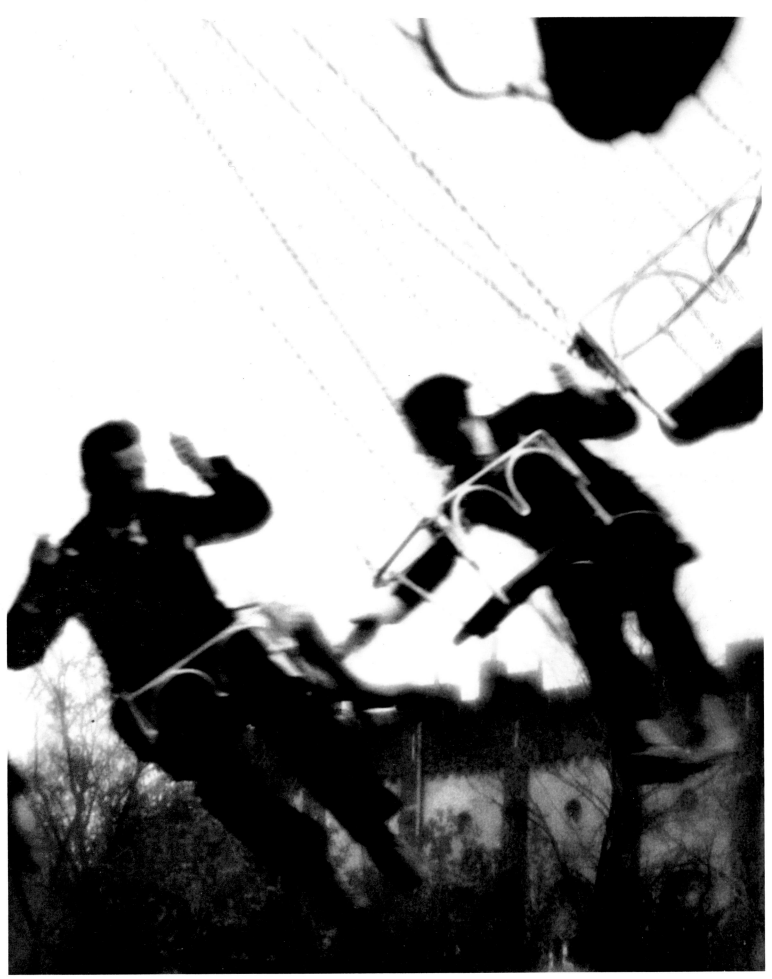

"Kettenkarussell (Amusement Park Ride)," Europe, c. 1928

Motorcycle race,
Europe, 1920s

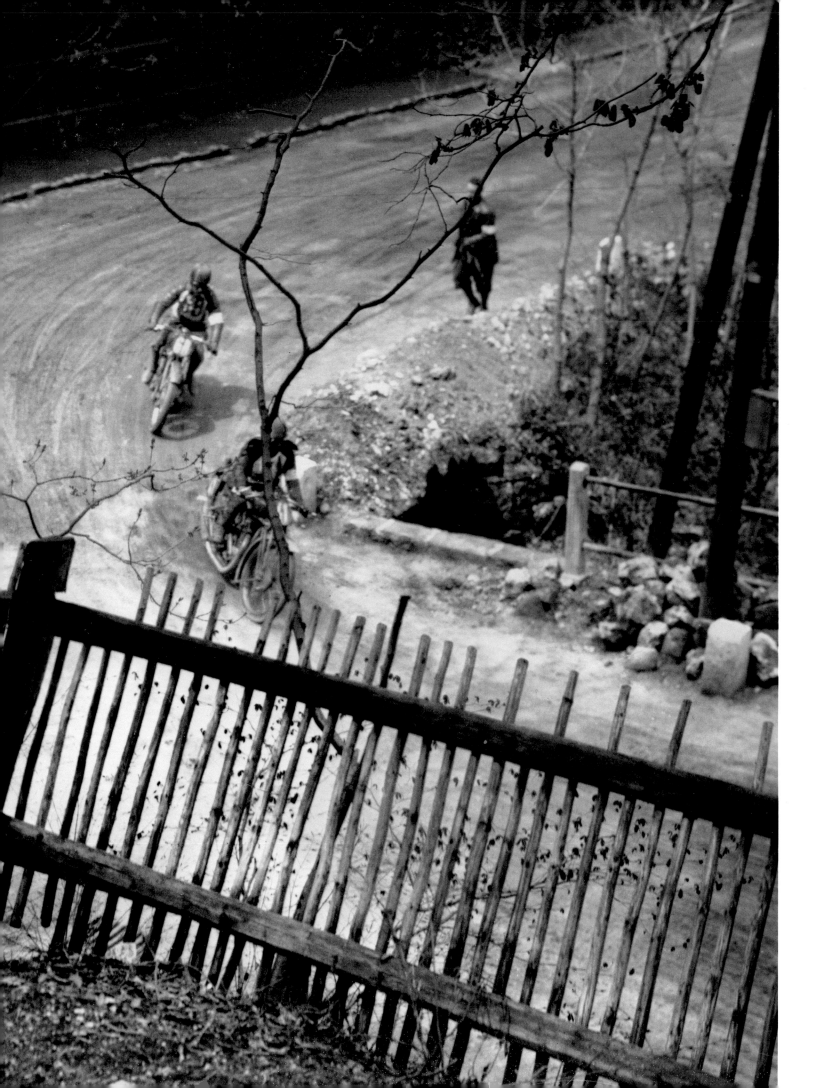

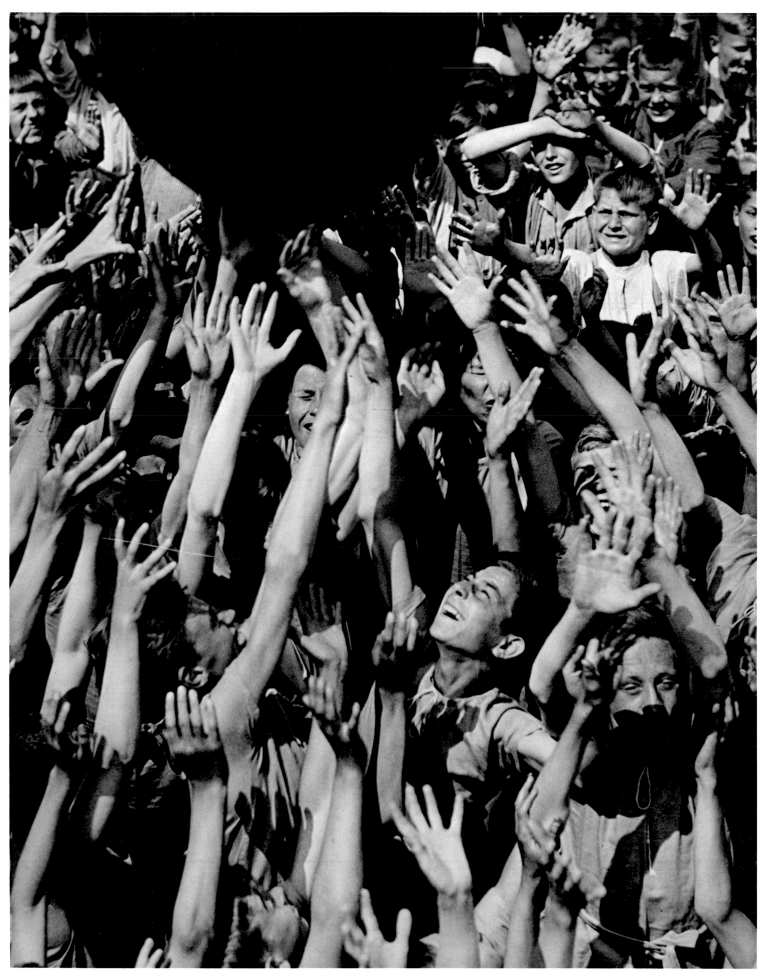

"Ferienfreude (Vacation Fun)," Germany, 1929

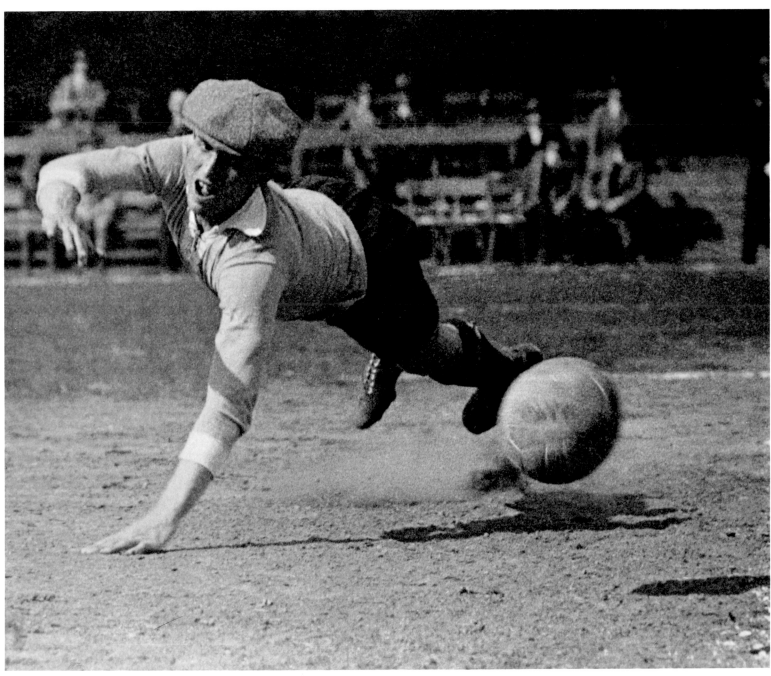

Soccer player, Hungary, c. 1923

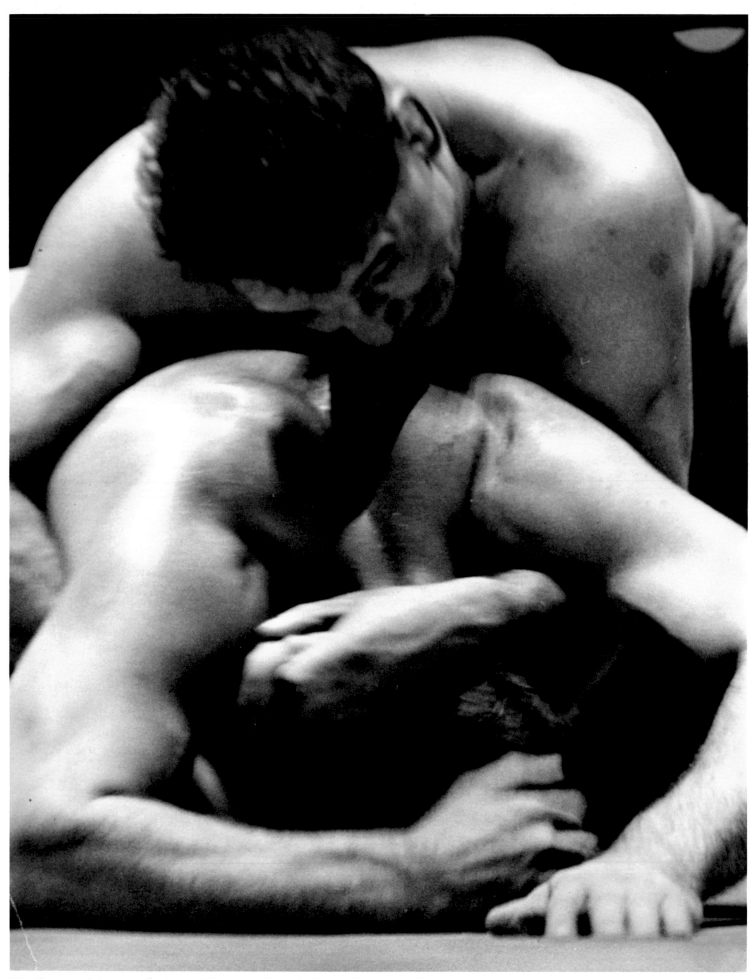

Wrestling match between Szabo and Browning, *Harper's Bazaar*, November 1935

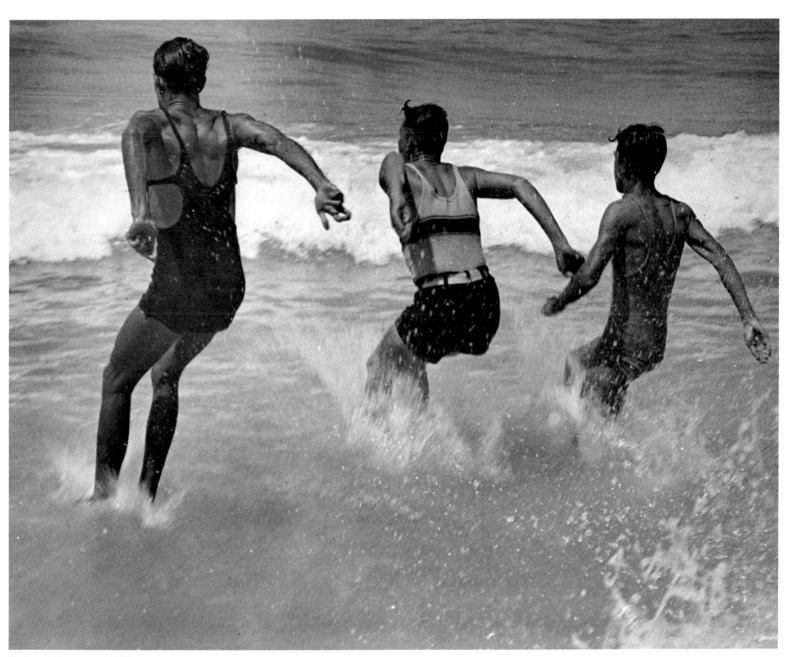

Bathers, Germany, 1929

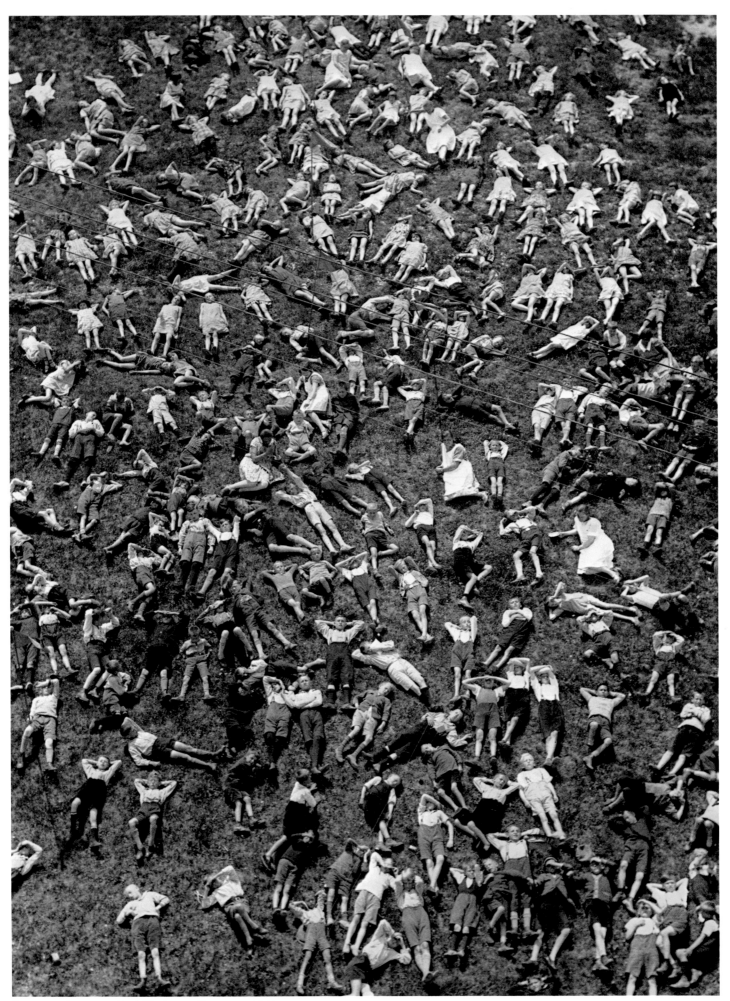

Summer camp, near Bad-Kissingen, Germany, 1929

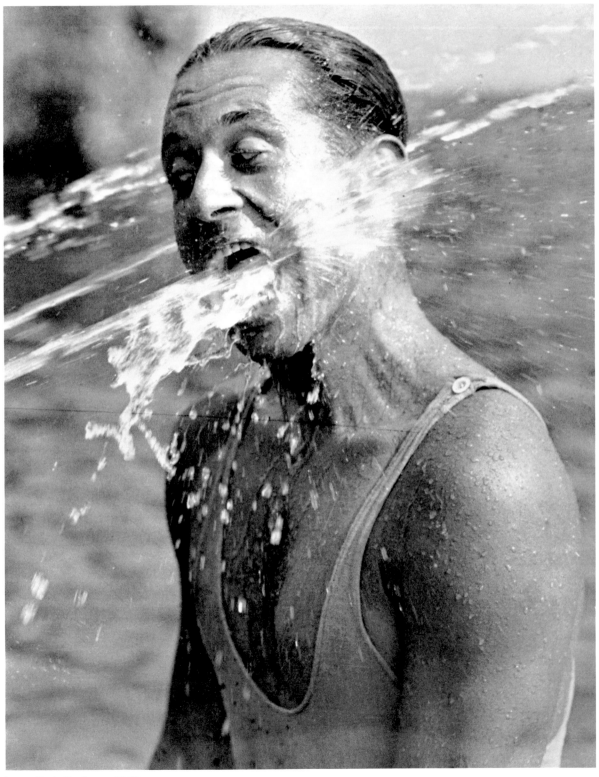

Luna Bad, Berlin, c. 1929

"SS Bremner 1929," Germany, 1929

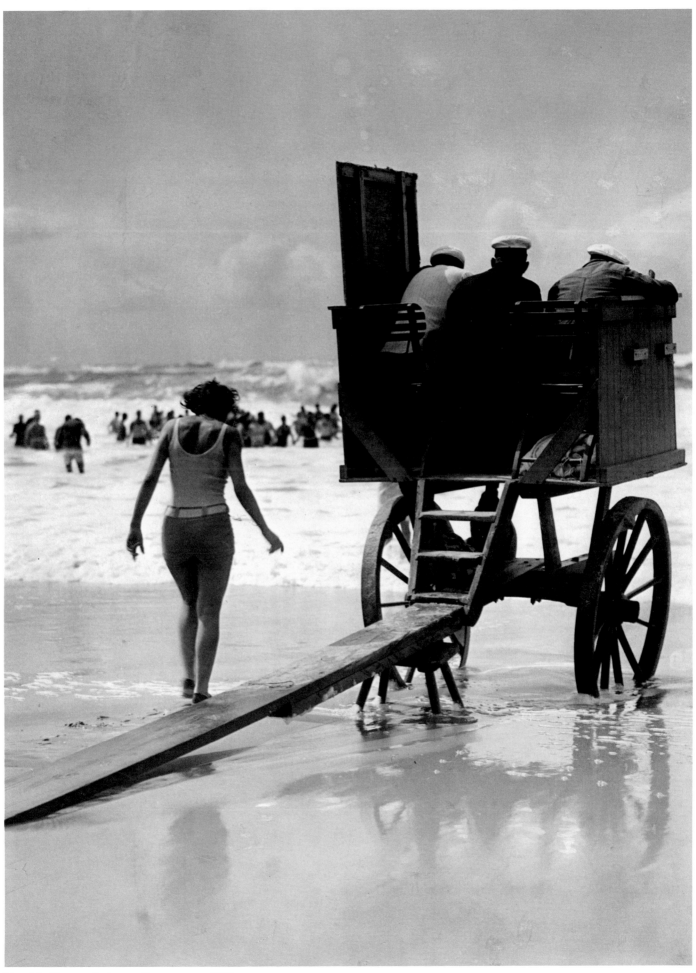

Movable lifeguard's tower, Germany, c. 1929

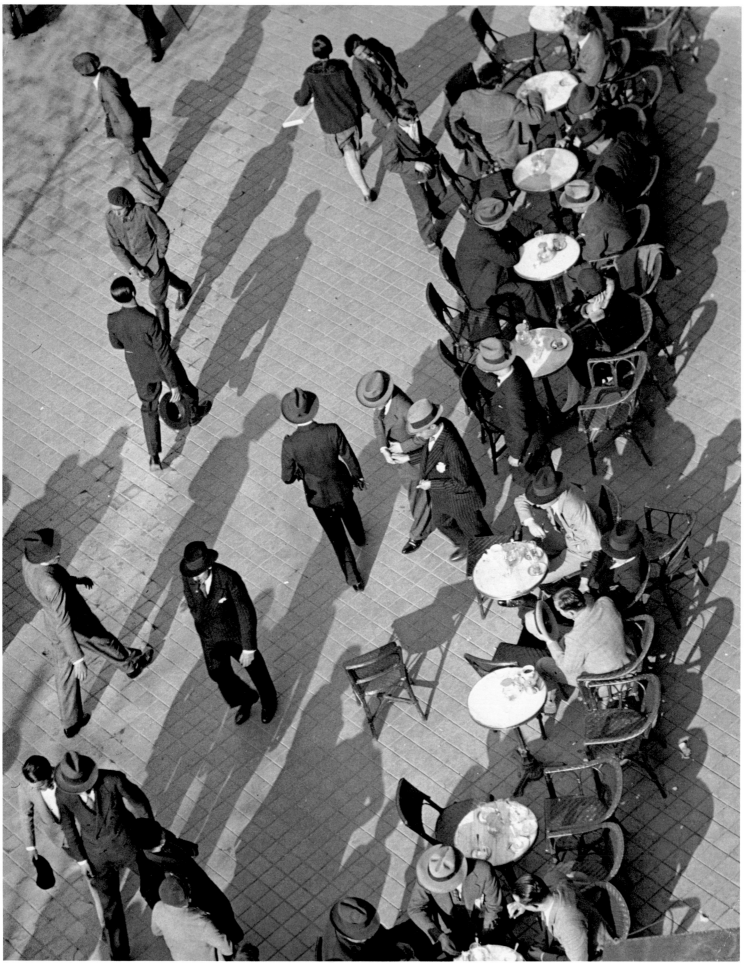

Unknown

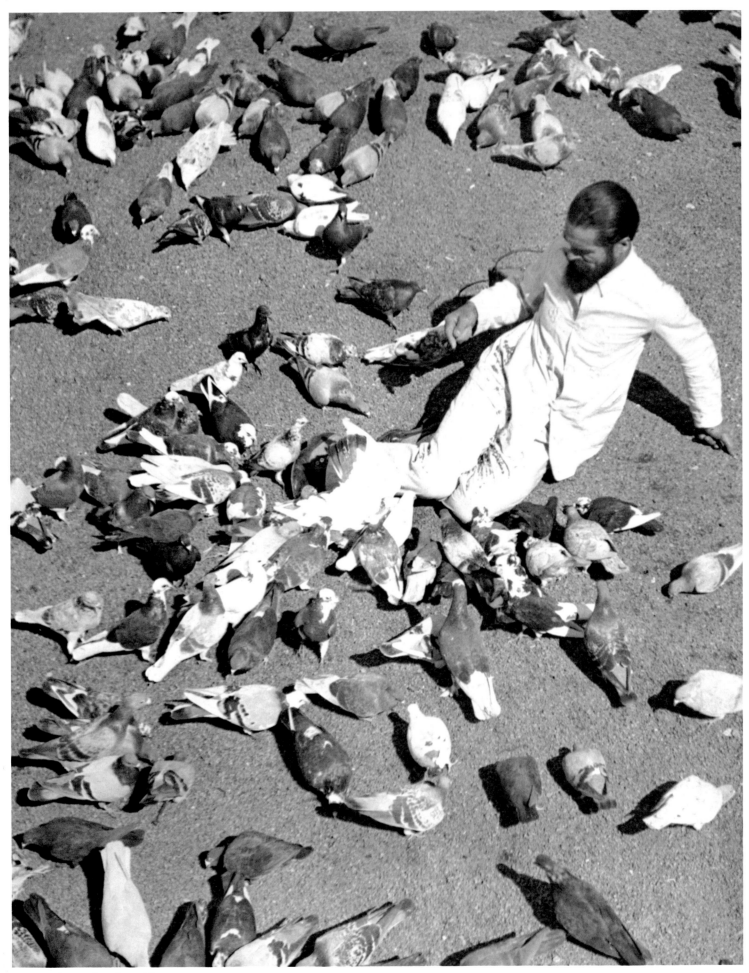

Rio de Janeiro, Brazil, 1932

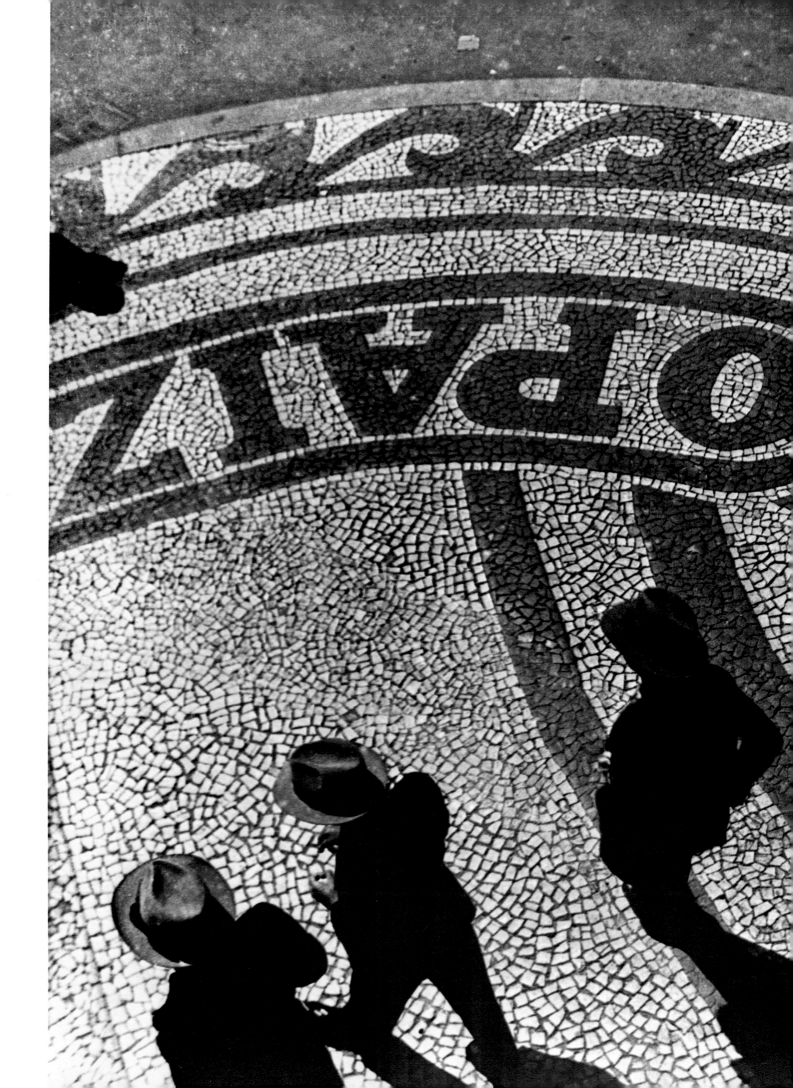

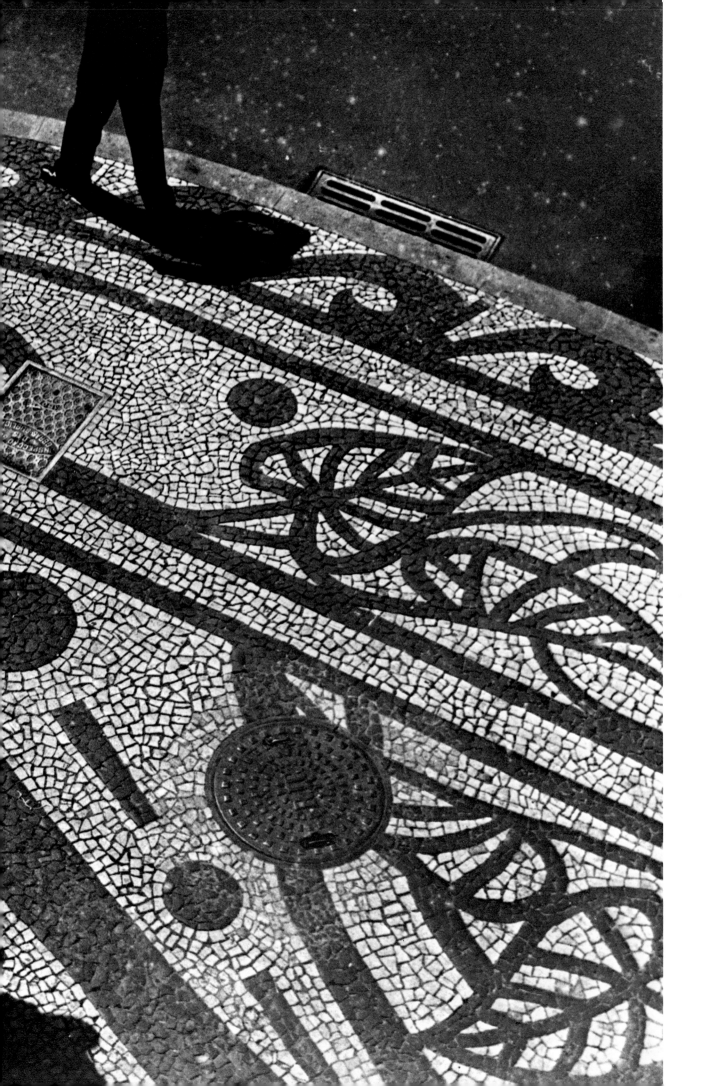

Rio de Janeiro,
Brazil, 1932

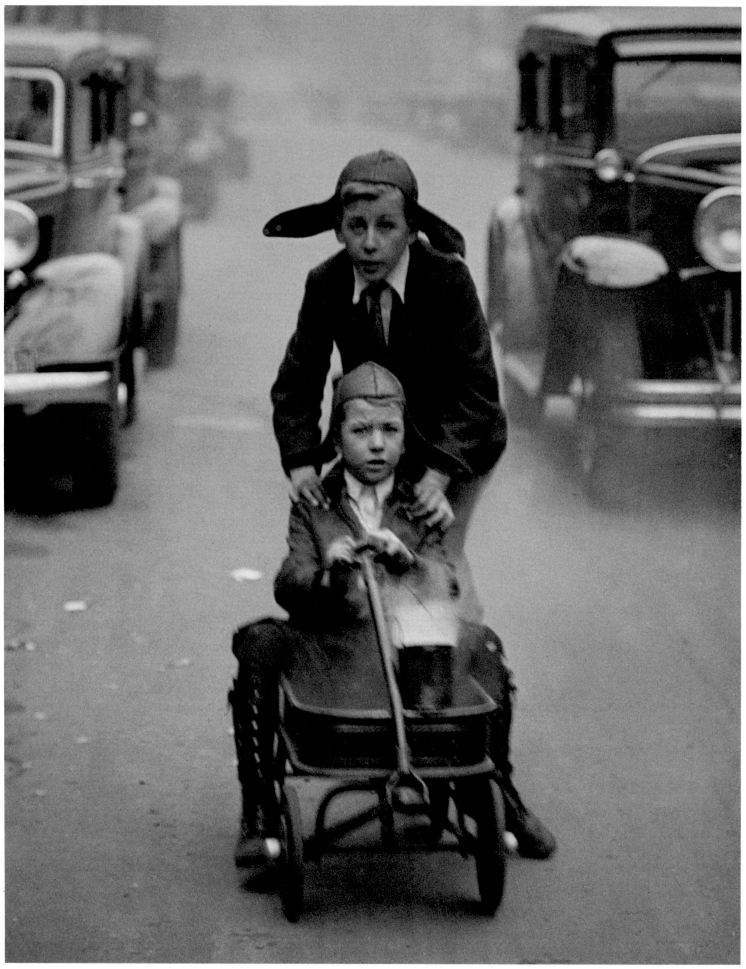

Madrid, 1930

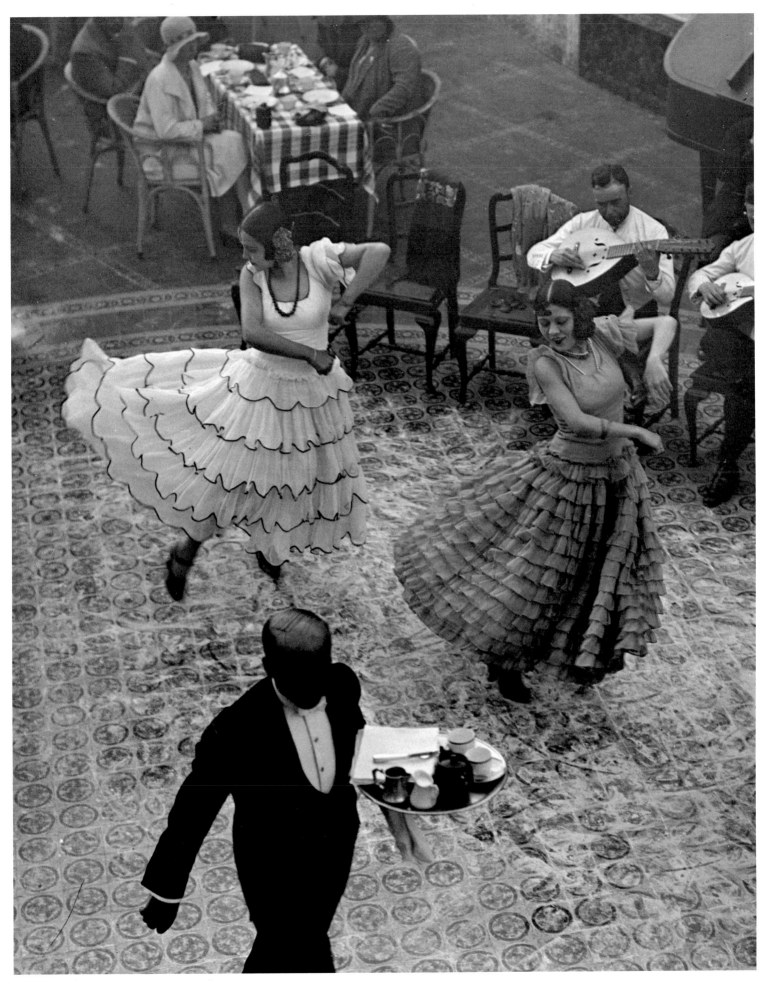

Dancers in Seville, 1930

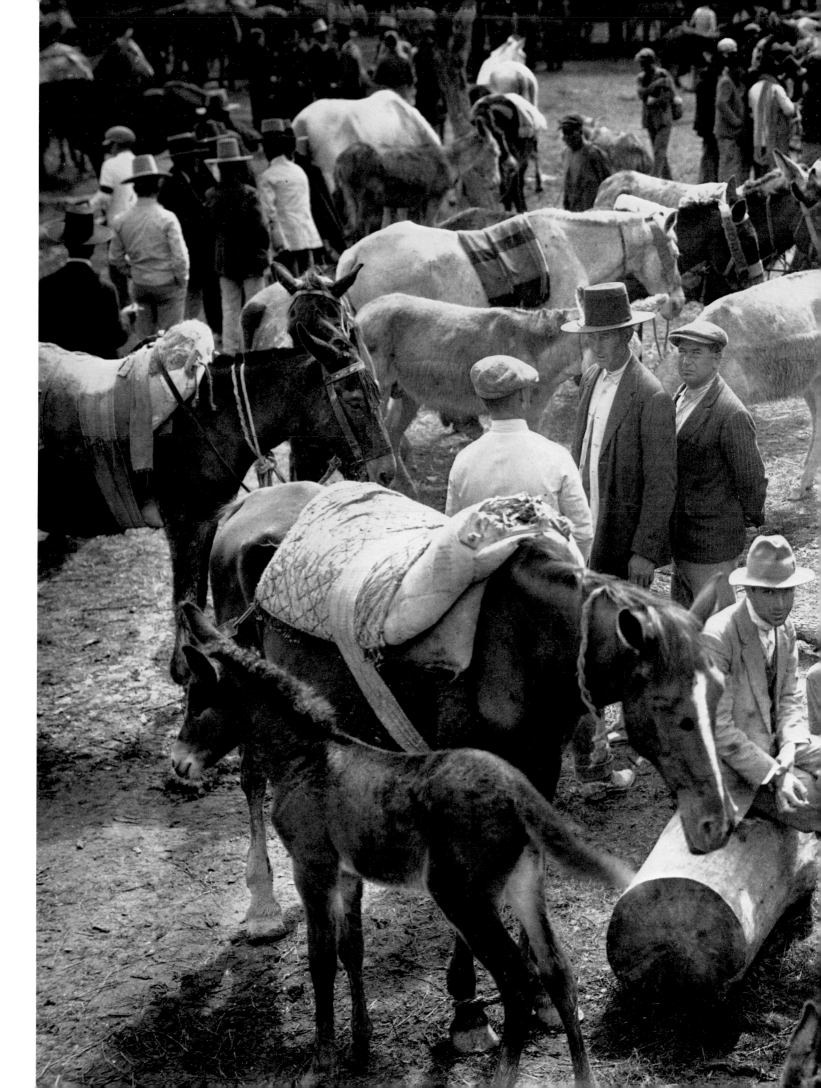

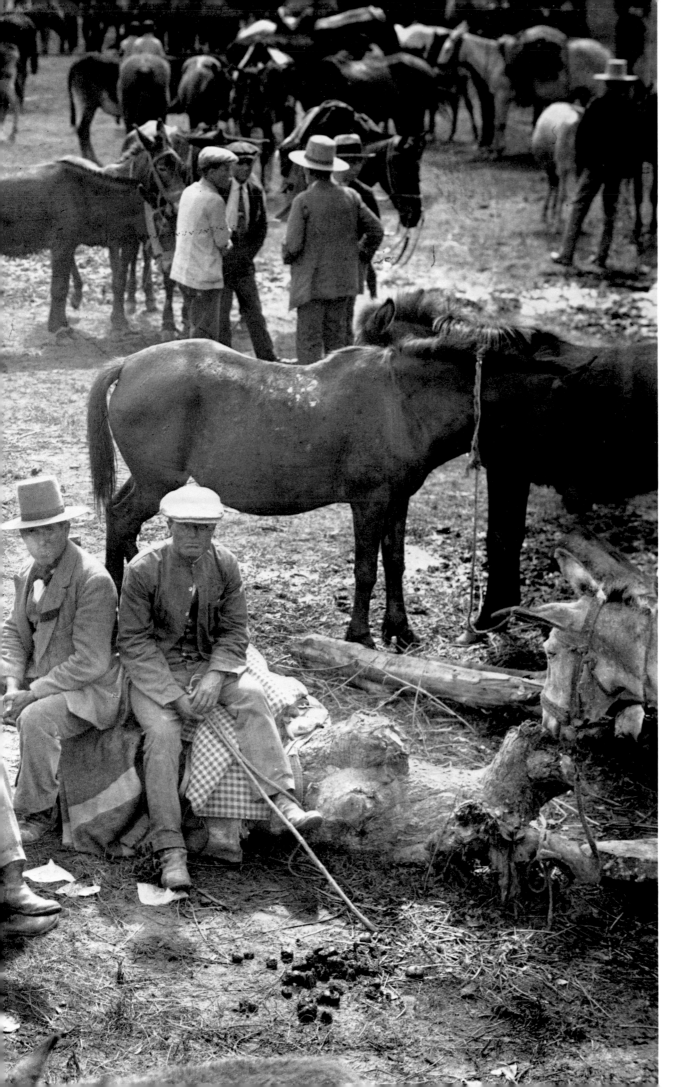

Horse market,
Seville, 1930

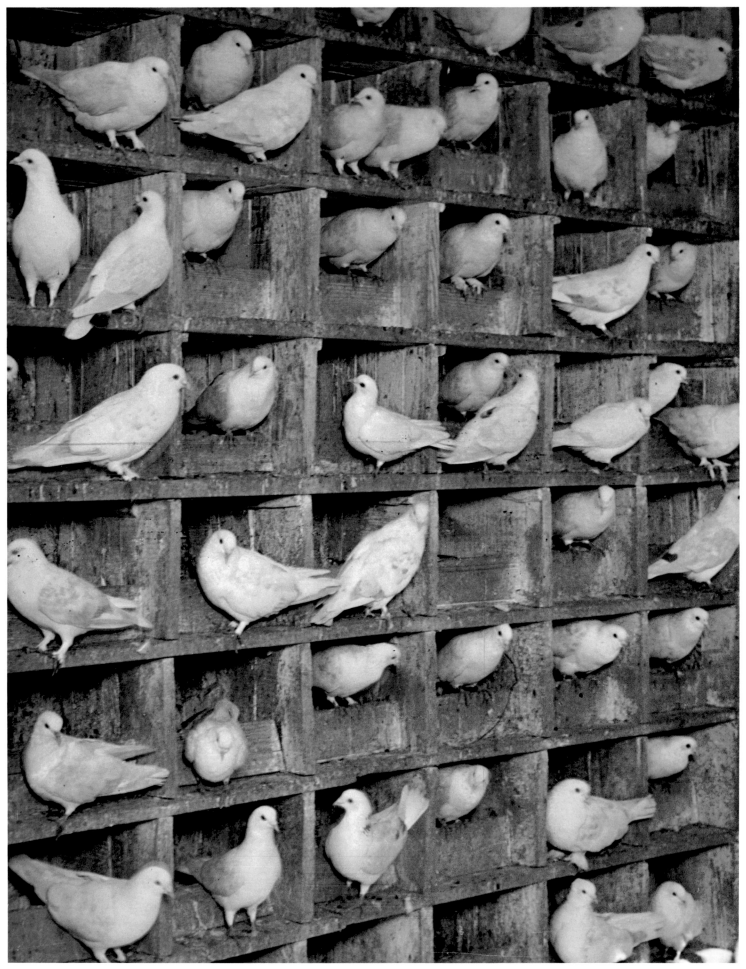

Unknown

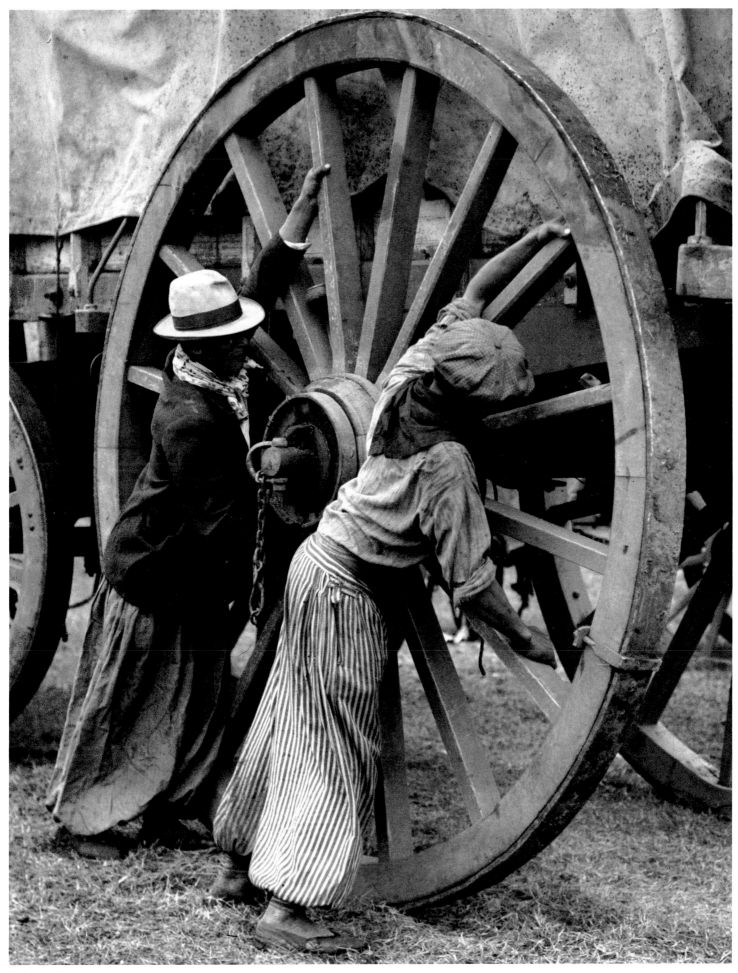

Turkey, 1929

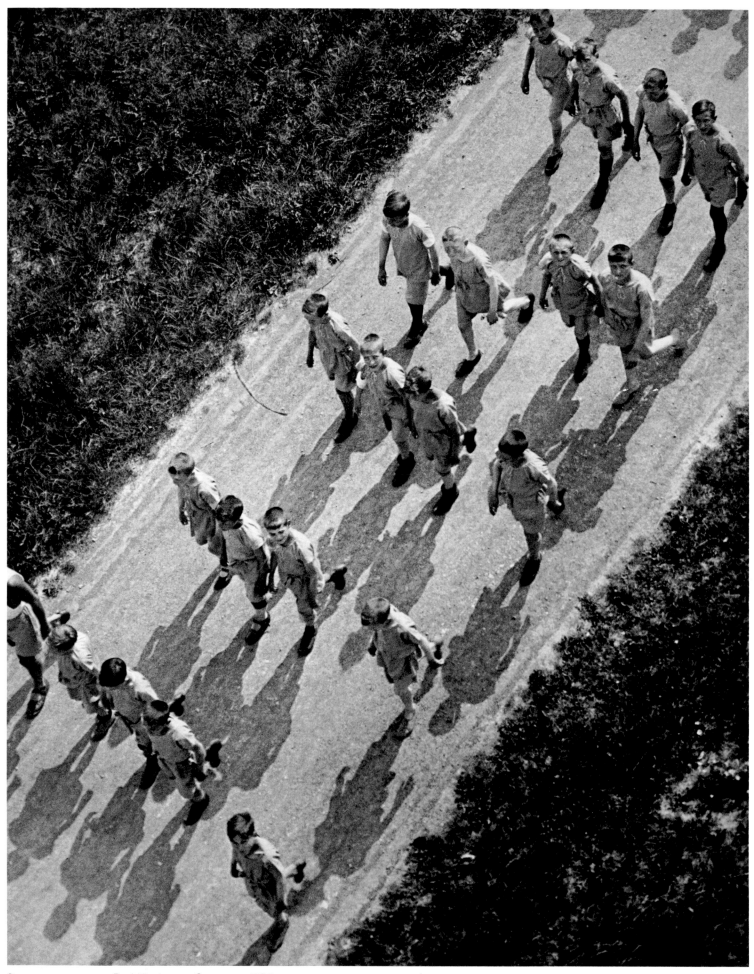

Summer camp, near Bad-Kissingen, Germany, 1929

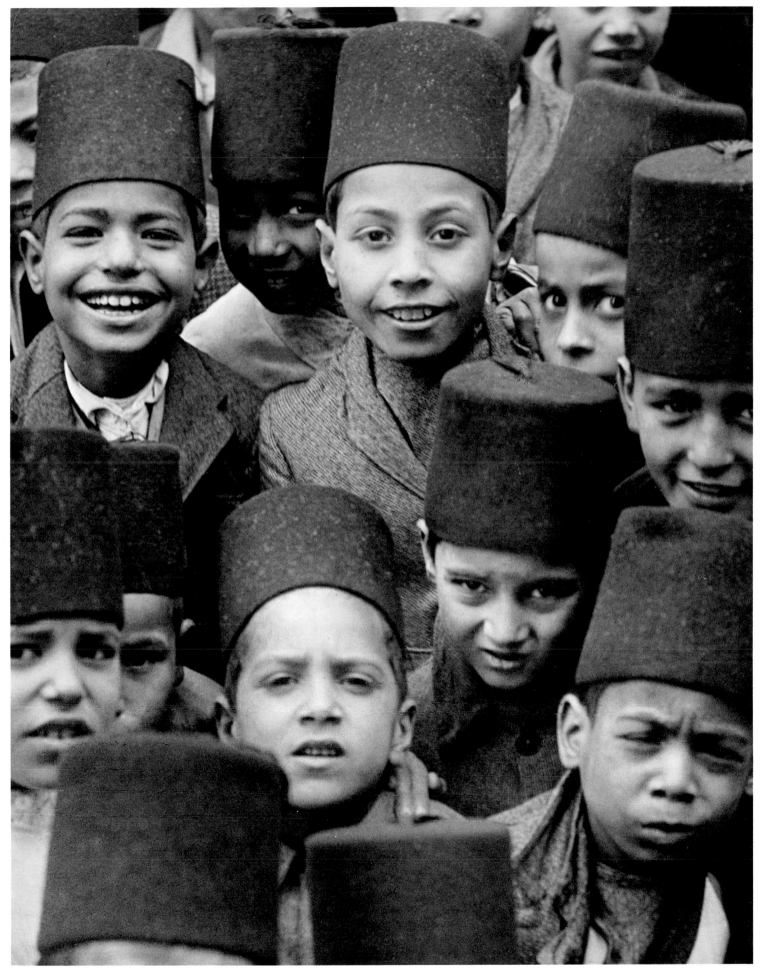

Turkey, 1929

"High Voltage," Germany, 1932

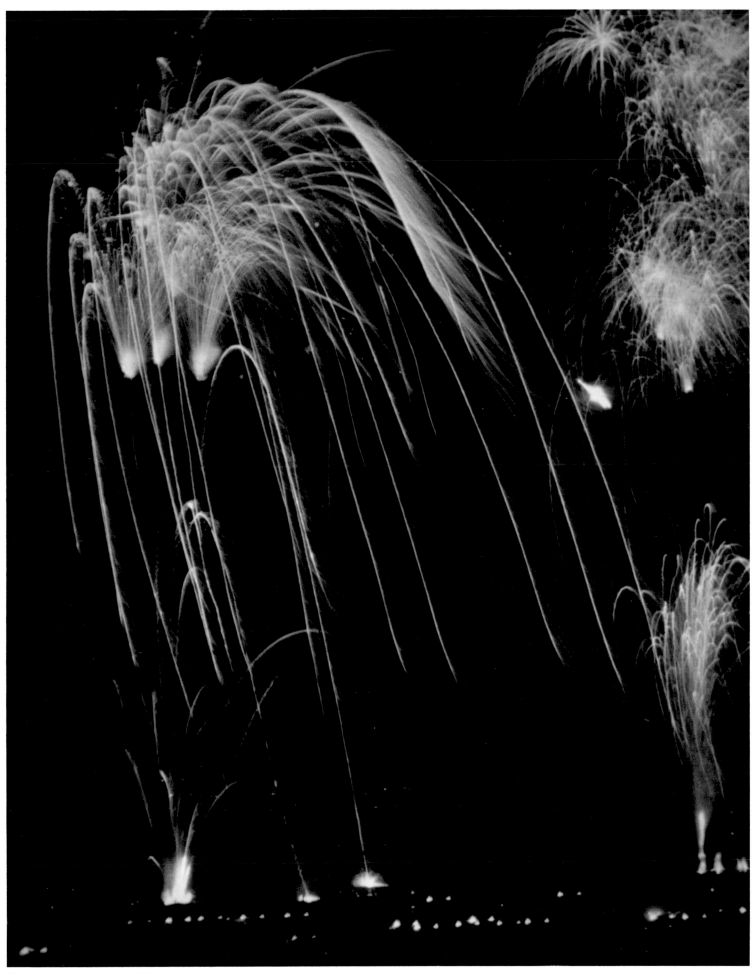

Fireworks over Berlin, c. 1930

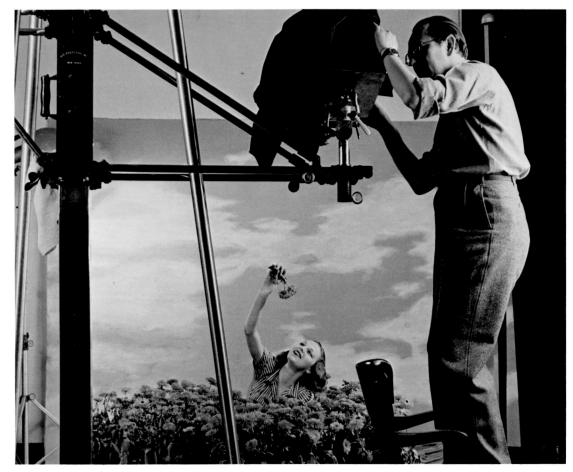

Munkacsi in studio with model, New York, c. 1940

If America's artists had exiled themselves in the 1920s, by the 1930s an extraordinary influx of talent—both foreign and domestic—established New York City as an international center for the arts.[14] Arriving from Berlin in 1931, Vicki Baum experienced the city as a veritable Tower of Babel: conversations took place simultaneously in German, French, and English.[15] In 1933, when Munkacsi was sent by Ullstein on assignment to the United States, the definitive American look in New York magazines was being invented by émigré imaginations.

Carmel Snow, from Dublin, had recently taken over as editor of *Harper's Bazaar*. Snow had been an editor at Condé Nast's *Vogue*; when she left to work for *Vogue*'s rival, published by the Hearst Corporation, the news of her resignation provoked hisses of "treason." At *Vogue* Snow had worked with Dr. Mehemed Fehmy Agha. A Turk educated at the art academy in Kiev, he was the art director for both *Vogue* and *Vanity Fair*. Dr. Agha's distinctly modernist vision had taught Snow not only to consider style in design but also to look for "life." The *Harper's Bazaar* she had inherited was drab and monotonous; she craved the opportunity "to get some fresh air in the book." She later recalled in her autobiography that her first great innovation at the magazine occurred after she noticed a newspaper advertisement for the B. Altman department store: "When I sent for the artist, Frederic Varady, he showed me some news photographs by a fellow Hungarian, Martin Munkacsi, that had appeared in *Die Dame*." Snow remembered that Edward Steichen, employed as chief photographer for Condé Nast, had been interested in Munkacsi's photojournalism. She asked Varady how to get in touch with Munkacsi and discovered that for exactly two days he would be in New York. "I remember my joy at thinking, this man is *here!*" Munkacsi, "who had never taken a fashion picture in his life," was hired by Snow to reshoot a bathing suit feature.

"The day I took those two Hungarians to the Piping Rock

Beach is a day I will never forget. The model was Lucile Brokaw, the first of the 'society' models that I found. The day was cold, unpleasant, dull—not at all auspicious for a 'glamourous resort' picture. Munkacsi hadn't a word of English, and his friend seemed to take forever to interpret for us. Munkacsi began making wild gestures. '*What does Munkacsi want us to do?* . . .' It seemed that what Munkacsi wanted was for the model to run toward him. Such a 'pose' had never been attempted before for fashion (even 'sailing' features were posed in a studio on a fake boat), but Lucile was certainly game and so was I. The resulting picture of a typical American girl in action with her cape billowing out behind her, made photographic history. . . . Munkacsi's was the first action photograph made for fashion, and it started the trend that is climaxed in the work of Avedon today."[16]

When the "Palm Beach" issue of *Harper's Bazaar* appeared in December 1933, William Randolph Hearst "summoned" Snow to San Simeon, his 275,000-acre megalomaniac retreat in California, to discuss Munkacsi's work. Munkacsi, still working on assignment for Ullstein in California, was also imperiously invited, "tucked away in Madame Recamier's bed in one of the guest rooms." He requested to photograph Hearst's mistress, Marion Davies, along with the weekend's assortment of houseguests, including Charlie Chaplin. One of the photographs from this visit shows Davies in the foreground, standing very still on a vast terrace. The background, an aerial view of a dramatically patterned brickwork, resembles earlier Munkacsi photographs taken in Brazil and Spain; but Miss Davies, a confection done up in tiers of white organza ruffles and marcel-waved platinum coiffure, resembles a fussy little doll on top of a wedding cake. Hearst dismissed Munkacsi as "just a snapshot photographer." Snow, however, believed in his work. She defied her publisher (and her own brother's advice about disagreeing with her employer) and offered Munkacsi a contract. Munkacsi turned down the offer and returned to Berlin. Six months later, in May 1934, he was back in New York. Munkacsi signed an exclusive contract with *Harper's Bazaar* and his work began to appear regularly in the magazine.

Under Carmel Snow's editorship, *Harper's Bazaar* became the most sophisticated fashion magazine of its time. *Bazaar* began to publish the writing of Colette, Christopher Isherwood, and Virginia Woolf; images were created for the magazine by Man Ray, Jean Cocteau, and Salvador Dalí. Diana Vreeland contributed her extravagant and hilariously frivolous advice column, "Why Don't You . . ." filled with such handy hints as: "Turn your old ermine coat into a bathrobe" and "Wash your blond child's hair in dead champagne, as they do in France."[17] The photographer Ralph Steiner introduced Snow to the work of Alexey Brodovitch, a graphic designer and former officer in the White Russian Army. Hired as the new art director in 1934, Brodovitch revolutionized the entire look of the magazine. He did away with boxy, old-fashioned layouts and introduced ambitious double spreads, bold type, and beauti-

fully cropped photographs. For the November 1935 issue, Brodovitch placed two rows of Munkacsi's photographs—the duo of Raymond and Renita, dancing with a free-swinging elegance—like film strips, running at angles across the pages. Working with Brodovitch, Munkacsi was able to introduce images into fashion that had never been seen there before: his models neatly leaped over rain puddles, posed dramatically under airplane wings, and emerged breezily from an ordinary supermarket with children and packages in tow. At *Harper's Bazaar* Brodovitch's designs and Munkacsi's images were ideally suited to each other.

Nancy White, Carmel Snow's niece and later the editor of *Harper's Bazaar*, remembered Munkacsi's outrageous charm, "matched only by his sense of humor."[18] A glamorous European, he was sophisticated but never blasé; deeply emotional and a tremendous amount of fun, he was considered something of a ladies' man. Munkacsi had married for the second time in Budapest, and his wife and daughter had made the trip from Berlin to New York with him. By 1936 his second marriage was dissolving; Munkacsi moved into his photography studio and began to live separately from his wife and daughter. Continuing to spend time with his daughter, he was with her on an outing to the Empire State Building in 1939 when she suddenly fell ill. Munkacsi brought her to a hospital, where she was diagnosed as having leukemia; she died three weeks later. In 1940 Munkacsi's second divorce became final. In 1942 he was married again, to his secretary, Helen Lazar, who had come to work for him while still a teenager. By that time Munkacsi had become one of the highest paid photographers in America.

"Think While You Shoot" was the title of a feature on photography tips by Munkacsi that was published in the November 1935 issue of *Harper's Bazaar*. He advised the readers, "Never pose your subjects. Let them move about naturally"—adding, with a rather confident impertinence in Mr. Hearst's own magazine, "All great photographs today are snapshots." As Munkacsi's fashion work garnered attention, he gained celebrity as a fashion photographer. "My trick—" he asks in the same article, "Is there one? Well, perhaps a bitter youth with many changes of occupation, with the necessity of trying everything from writing poetry to berry picking. These difficult early years probably constitute the sources of my modest photographic activity."[19]

Munkacsi created a clever self-portrait at this time: he posed himself, floating on his back in the water, with his camera balanced on his belly (he is not simply using a camera, he is using himself as tripod as well). Although someone else has obviously released the shutter, it is Munkacsi's photograph. The caption read: "The author somewhere on Long Island, on a cold, cold day in late October, risks his life for his art and the Palm Beach bathing suits."[20] It is an amusing, genuinely buoyant image—the photographer, bobbing along in a sea of change, a self-portrait in studied spontaneity.

"The modern picture is a result of cutting," Munkacsi de-

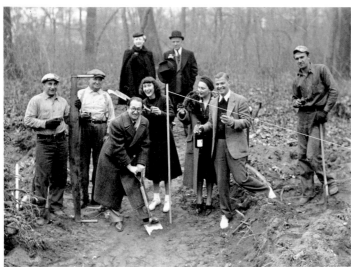

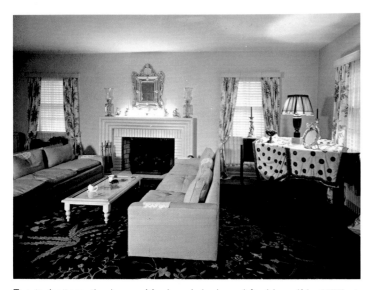

Top to bottom: the house Munkacsi designed for himself in 1939 at Sands Point, Long Island; the ground-breaking for the house; and the living room.

clared. He would blithely crop away entire sections of a print and use just a fraction of the original negative to achieve his desired effect. In a 1935 photograph for *Bazaar*, a model in sheer night clothes poses out of doors; her arms are lifted over head, like a couturier's vision of a caryatid, as the wind swirls her peignoir dreamily about her body. This reverie is disrupted when the entire frame of the picture is shown; the seductive breezes teasing the model's clothes are actually a stern-looking photo stylist, a woman dressed in tweeds and sensible shoes, who has run out of the picture like a true professional. Munkacsi was now fully fashioning the images, simulating the impromptu attitude he had first been able to capture as a photojournalist.

Starting in 1934, Munkacsi worked out of a triplex penthouse studio at 5 Tudor City Place. The Tudor City apartment complex had been built in the late 1920s by New York real estate developer Fred French. The area, in Manhattan's East 40s, was not yet fashionable. There were still slaughterhouses along the river's edge, and the water was regularly used as a dumping ground; Munkacsi was given a year's free rent when he signed his lease. (Around the same time, Dorothy Parker moved to an apartment on East 52nd Street near the river and wisecracked that "it was so far east you could plant tea.") The developer's idea for Tudor City was that it would be a hotel/apartment; the apartments, except for the penthouse triplexes, were small, but the building provided maid service, on-site restaurants, and its own park with miniature golf course. Tudor City, a half-timbered high rise, an old-world architectural homage combined with ambitious modernism, was the ideal studio location for Munkacsi. And, in keeping with the accelerated times, the neighborhood transformed itself and became stylish.

In 1939 Munkacsi also built a house in Sands Point, Long Island. In *The Great Gatsby*, F. Scott Fitzgerald's classic novel about prosperity, self-invention, and failed dreams, Sands Point provided the prototype for East Egg: "It was on that slenderous riotous island which extends itself due east of New York—and where there are among other natural curiosities, two unusual formations of land. Twenty miles from the city a pair of enormous eggs, identical in contour and separated by a courtesy bay, juts out of the most domesticated body of salt water in the Western Hemisphere, the great wet barnyard of Long Island Sound. . . . I lived at West Egg—well the less fashionable of the two. . . . Across the courtesy bay the white palaces of fashionable East Egg glittered along the water."[21] In his own "white palace" Munkacsi built a curved glass window (claiming it as the first curved glass wall in a private residence in the United States). The decorating scheme was an ebullient mix of *haute monde* and country casual: Old Master paintings and Ming Dynasty sculptures shared space with Hungarian folk pottery and English chintz upholstery. As John Esten remarked, "Munkacsi had the interests, vitality, and ego of five people."[22]

In 1940 Munkacsi received a $4000-per-month contract from *Ladies' Home Journal* to photograph their popular lifestyle fea-

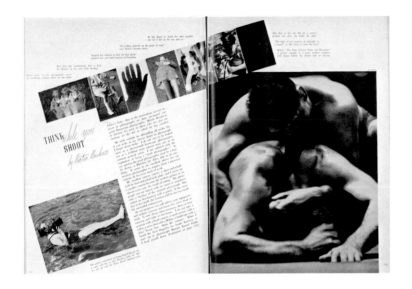

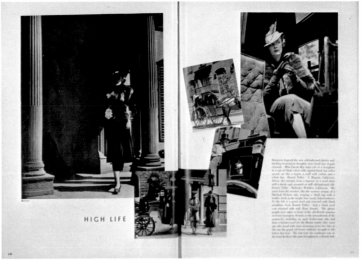

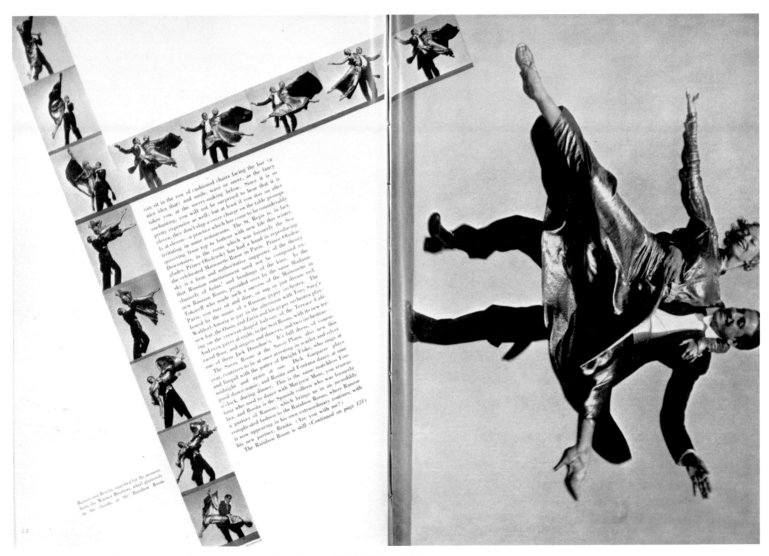

Munkacsi spreads from *Harper's Bazaar* designed by Alexey Brodovitch, 1930s

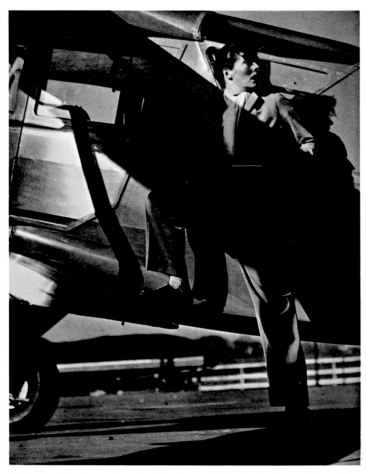

Katharine Hepburn standing by Howard Hughes's plane, *Harper's Bazaar*, February 1935

growing up in a town where lunatics are boarded with the local residents. Munkacsi looks back on his own childhood in Dicsö-Szent-Marton with an enervating introspection. The book is situated clumsily between a folk tale and a modern novel. Munkacsi wrote in English and the manuscript was revised to make the language more colloquial; the result, however, reads like an awkward translation. Munkacsi had always wanted to be a writer; during his childhood in the provinces, when reading must have provided an escape to the wider world, he fancied himself a romantic poet. By the time he wrote *Fool's Apprentice*, World War II had ended and he was a middle-aged man recovering from a heart attack, trying to gather up his now irretrievable European past. As a photographer, his work revealed a keen, responsive edge; as a writer, working alone, his gift for observation fell into unbridled sentimentality and regret.

Munkacsi's contract with *Ladies' Home Journal* ended in 1946, when the pages of the magazine were taken over almost entirely by color photography. Although his work for "How America Lives" had been included in sixty-five out of seventy-eight monthly issues (1940–1946), he was unable to make the transition from black-and-white to color. The following year *Harper's Bazaar* did not renew his contract. According to one of Munkacsi's succinct anecdotes, he had infuriated the editors by refusing to photograph Presidential candidate Thomas E. Dewey for the magazine, declaring that he would not take a picture that would make a Republican look good. He worked as a freelance photographer for the Reynolds Company, King Features, and the Ford Motor Company, and as a cameraman and lighting director for film, including a stop-action-animation puppet feature of *Hansel and Gretel*. He wrote and directed his own film, *Bob's Declaration of Independence,* a set of archly humorous etiquette lessons for children, but it was never released. In the 1930s Munkacsi was billed as the "highest paid photographer in America," but he had never saved any money. His daughter Joan, born in 1948, recalls her father pawning cameras to buy birthday presents and being evicted from a string of Manhattan apartments.

In 1956 Munkacsi was divorced unhappily for a third time. He was sixty years old, and the radical changes he had introduced into fashion photography were now accepted as the standard. In the 1957 movie musical *Funny Face*, when the fashion photographer (played by Fred Astaire) commands the reticent model (played by Audrey Hepburn) to run through the rain, the moment is pure Munkacsi. From the film's lively opening credits, designed by Richard Avedon (self-described as Munkacsi's "heir"), Munkacsi's influence is clear; but by 1957 Munkacsi's influence had eclipsed his own career.

Munkacsi did, however, continue to work. He was sent by mainstream American magazines to photograph on film locations; he covered Otto Preminger's *Exodus* and Henry King's *Tender Is the Night* (an unsuccessful adaptation of F. Scott Fitzgerald's novel set in the South of France). His third divorce

ture, "How America Lives." He was said to be earning more than $100,000 a year and liked to quip, "A picture isn't worth a thousand words, it's worth a thousand bucks!" In 1934 Munkacsi had worked with Kurt Safranski, the former managing editor at Ullstein, on a dummy for a Hearst Corporation picture magazine; Hearst turned down the project and in 1935 gave them permission to submit their idea to Henry Luce. When *Life* magazine developed out of this proposal, Safranski became *Life's* managing editor and Munkacsi began photographing for this direct descendant of the *Berliner Illustrirte Zeitung*. Munkacsi's work was influencing mainstream American culture. A *Saturday Evening Post* short story published in 1940 began: "Julie came into the room, her cape slung back like a photo by Munkacsi"; at Condé Nast, Dr. Agha remarked that "Munkacsi's coming to America was the most important thing that has happened to American photography in the past ten years."[23]

Munkacsi suffered his first heart attack in 1943. Unable to return to work, he devoted his time to writing. In 1945 the Reader's Press published his allegorical, autobiographical novel, *Fool's Apprentice*. Imre, the "fool's apprentice," is a boy

was especially difficult for him; he filed lawsuits for custody of his daughter and lost. In the late fifties, following the failed Hungarian revolt of 1956 against the Communist regime, he sent parcels to his son by his first marriage; they had not seen one another for years. Munkacsi's life was shaped by what Nabokov refers to as the child's "dream of velocity"; he had propelled himself swiftly from his own past, boldly entered an ever-widening world, and captured its rhythms. His talent was never lost, but his sense of the times had faltered. Munkacsi took one of his last photographs for *Harper's Bazaar* in 1962. With his daughter Joan and a fashion model, he drove out from New York City to a little cove at Sands Point. The model, dressed in a bathing suit and a turban designed by Halston, posed according to Munkacsi's precise but always intuitive directions. This was the only time Joan Munkacsi assisted her father on a fashion shoot. "He shot only four or five pictures," she remembers. "The model changed into another bathing suit and a different headdress. My father told her where and how to stand, shot five more pictures, and then we all got into the car and went to lunch." In a brief moment Munkacsi could still discern the instinctual grace of an image.

That same year, at the 57th Street Horn and Hardart Automat in Manhattan, Munkacsi was approached by the photographer Hiro. Hired by Brodovitch to work at *Harper's Bazaar* in 1954, Hiro was an enthusiastic admirer of Munkacsi's work. This was a perfect unplanned encounter: the meeting of two generations of émigré photographers at an Automat, where "it was still fun to put your nickels in the slot, open the little glass door and extract your lemon meringue pie, and the brass dolphin-head spouts through which coffee flowed still managed to give an impression of the shape of things to come,"[24] has the serendipitous delight of a Munkacsi photograph.

On July 14, 1963, Munkacsi was at Randall's Island, attending a Hungarian team's soccer match, when he suffered a heart attack. He was taken to a Manhattan hospital, where he died later the same day of a second attack. In June 1964, *Harper's Bazaar* published a memorial to his work, and Richard Avedon wrote: "The Art Department of *Harper's Bazaar* is a particularly enthusiastic place, hell-bent for discovering the New. The morning after Munkacsi's death, bound volumes of vintage *Bazaar* filled the office. His women, laughing out of their pages, dazzled the drawing boards. The breadth of his dogwood, the crash of his seas, assaulted the desks, the windowsills, the floor, and the young Art Directors. That morning they discovered Munkacsi! *I wish he could have been there. I wish he could have seen their eyes.* He wanted his world a certain way, and what a way! He saw what was free in it, happy in it, and however much he suffered, and he did suffer, his pain never destroyed his dream. Without illusions there would be no art and possibly no life in the world. The art of Munkacsi lay in what he wanted life to be, and he wanted it to be splendid. And it was."[25]

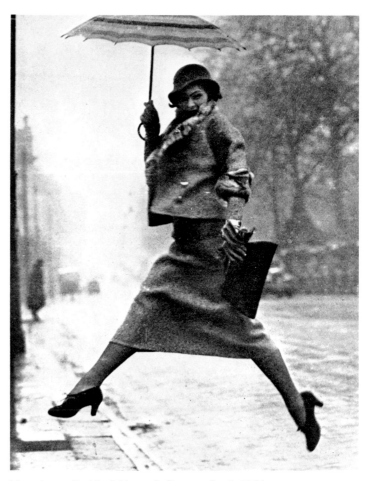

"Jumping a Puddle," *Harper's Bazaar*, April 1934

1. Martin Munkacsi, *Fool's Apprentice*. (The Readers Press, New York, 1945), p. 133. **2.** Robert W. Marks, "Portrait of Munkacsi," (*Coronet*, New York, January, 1940), pp. 25–26. **3.** Peter Gay, *Weimar Culture: The Outsider as Insider* (Harper & Row, New York, 1968), p. 128. **4.** *Ibid.*, p. 131. **5.** Vicki Baum, *It Was All Quite Different Then* (Funk and Wagnalls, New York, 1964), p. 264. **6.** Peter Gay, *op. cit.*, p. 134. **7.** G. Herbert Taylor, ed., *My Best Photograph and Why* (Dodge, New York, 1937). **8.** *Ibid.* **9.** Henri Cartier-Bresson, letter to Joan Munkacsi, May 25, 1977. **10.** Martin Munkacsi, "Think While You Shoot," (*Harper's Bazaar*, New York, November, 1935), p. 92. **11.** Van Deren Coke, *Avant-Garde Photography in Germany 1919–1939* (Pantheon Books, New York, 1982), p. 8. **12.** Peter Gay, *op. cit.*, p. 133. **13.** *Ibid.*, p. 133. **14.** Virgil Thompson, *Virgil Thompson* (Alfred A. Knopf, New York, 1966), p. 337. **15.** Vicki Baum, *It Was All Quite Different Then*, p. 331. **16.** Carmel Snow, *The World of Carmel Snow* (McGraw-Hill Book Company, New York, 1962), pp. 88–90. **17.** *Ibid.*, p. 112. **18.** Nancy White, introduction to *Style in Motion: Munkacsi Photographs of the '20s, '30s and '40s* (Clarkson N. Potter, New York, 1979). **19.** Martin Munkacsi, "Think While You Shoot," pp. 92–93. **20.** *Ibid.* **21.** F. Scott Fitzgerald, *The Great Gatsby* (Charles Scribner's Sons, New York, 1968), pp. 8–9. **22.** Colin Naylor, ed., *Contemporary Photographers* (St. James Press, London, 1988), pp. 731–32. **23.** Dr. Agha quoted in *Avant-Garde Photography in Germany*, p. 41. **24.** Jan Morris, *Manhattan '45* (Oxford University Press, 1987), p. 42. **25.** Richard Avedon, "Munkacsi," (*Harper's Bazaar*, New York, June, 1964), p. 68.

Harper's Bazaar,
June 1936

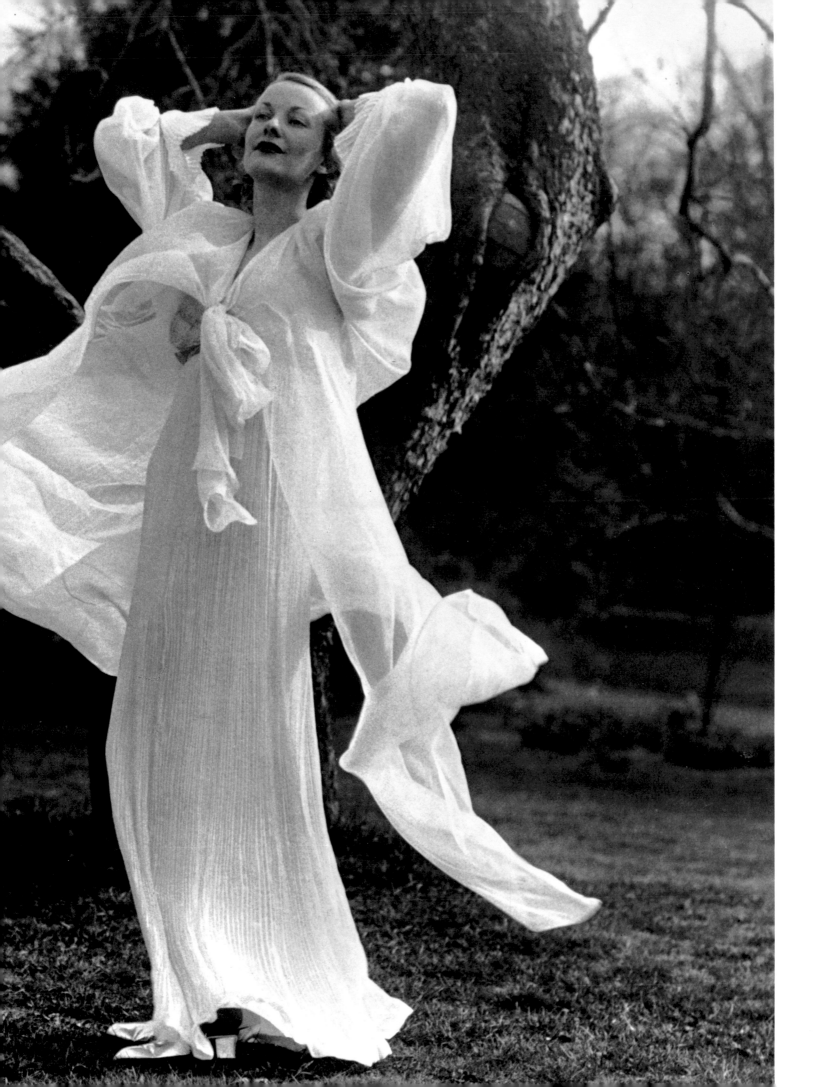

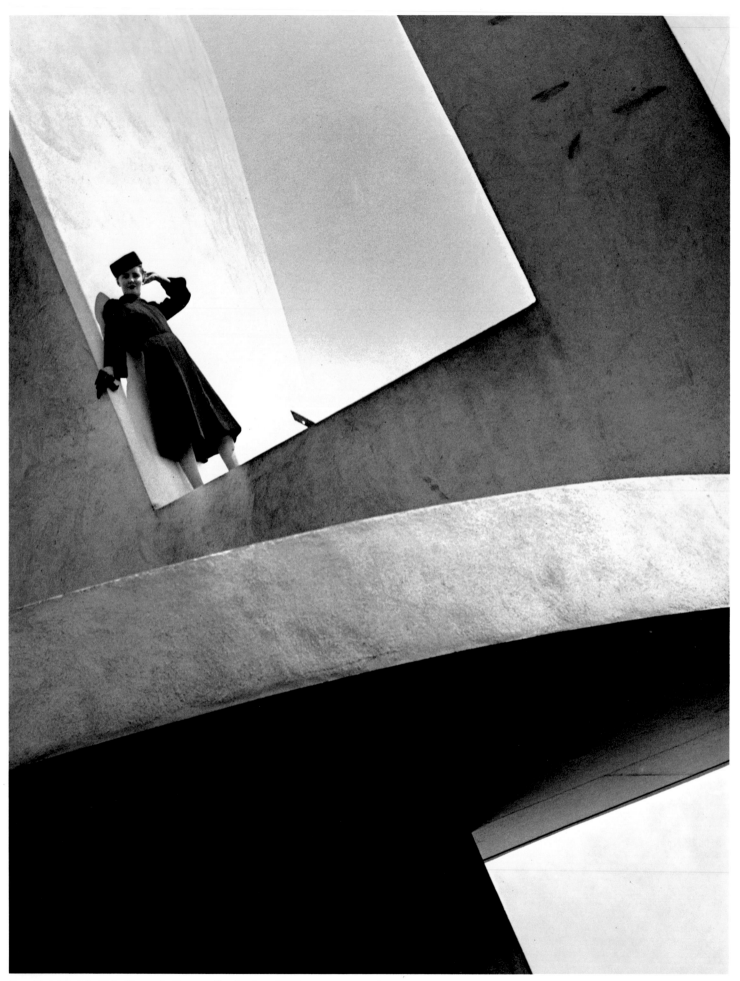

New York World's Fair, *Harper's Bazaar*, September 1938

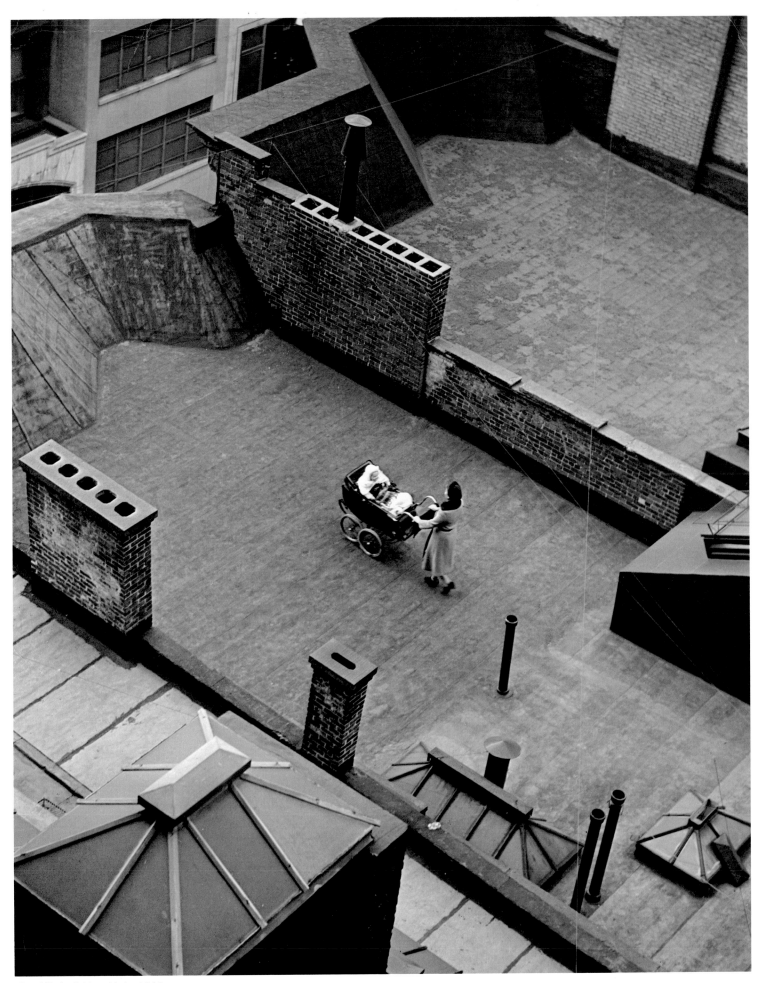

"Roof Baby," New York, 1940

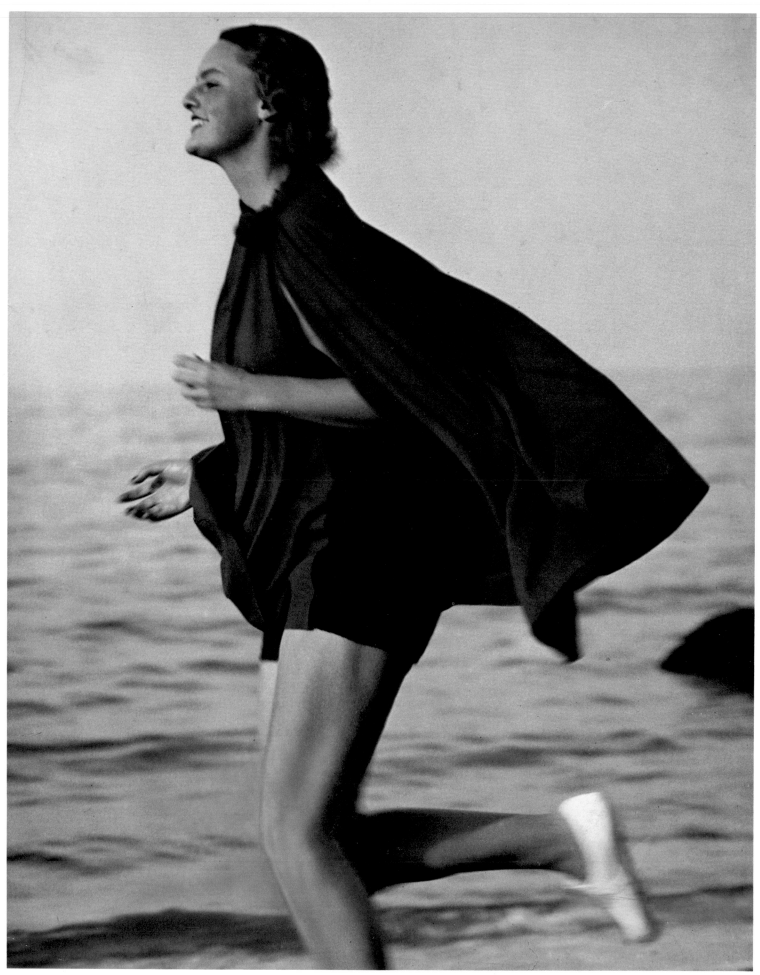

Munkacsi's first fashion photograph (of model Lucile Brokaw), *Harper's Bazaar*, December 1933

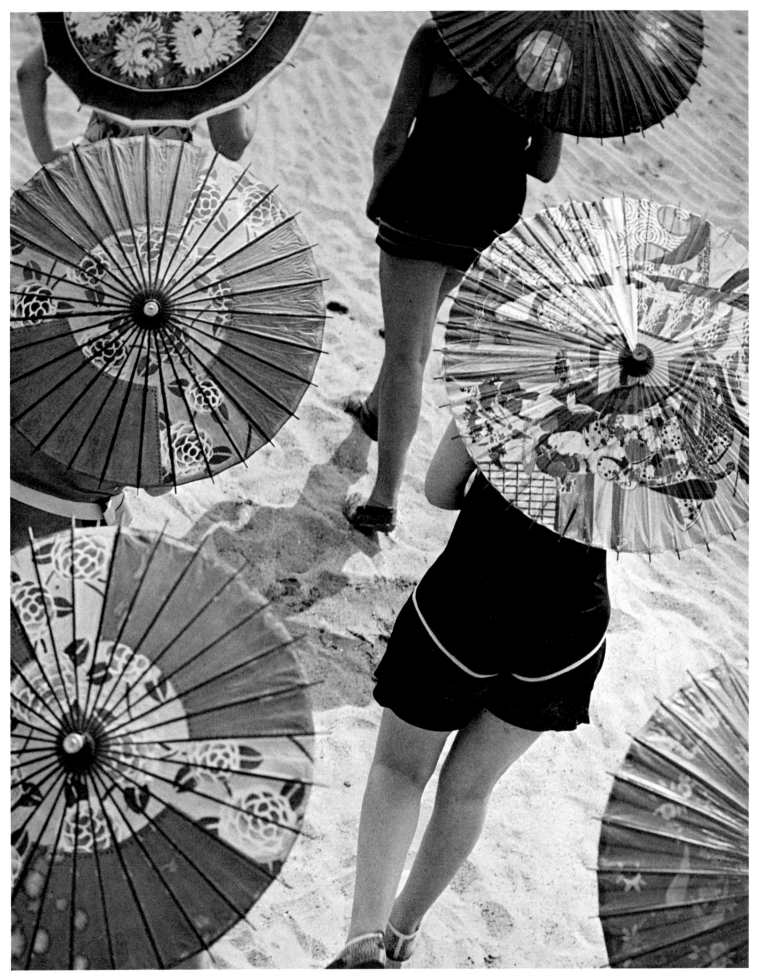

Europe, c. 1922–33

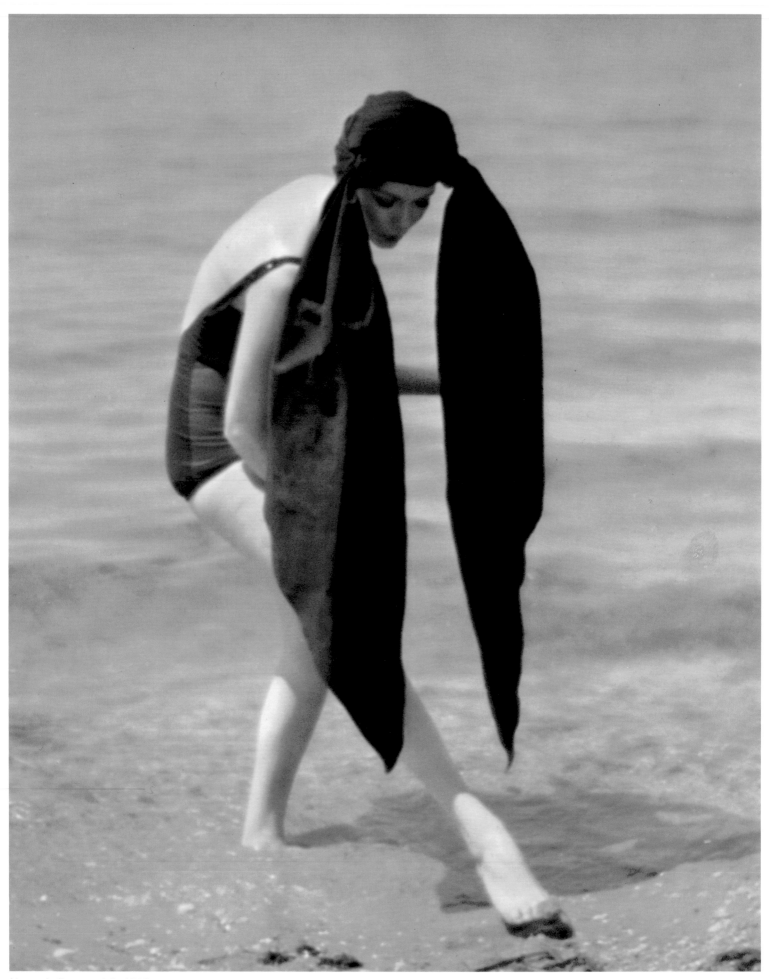

Harper's Bazaar, July 1962

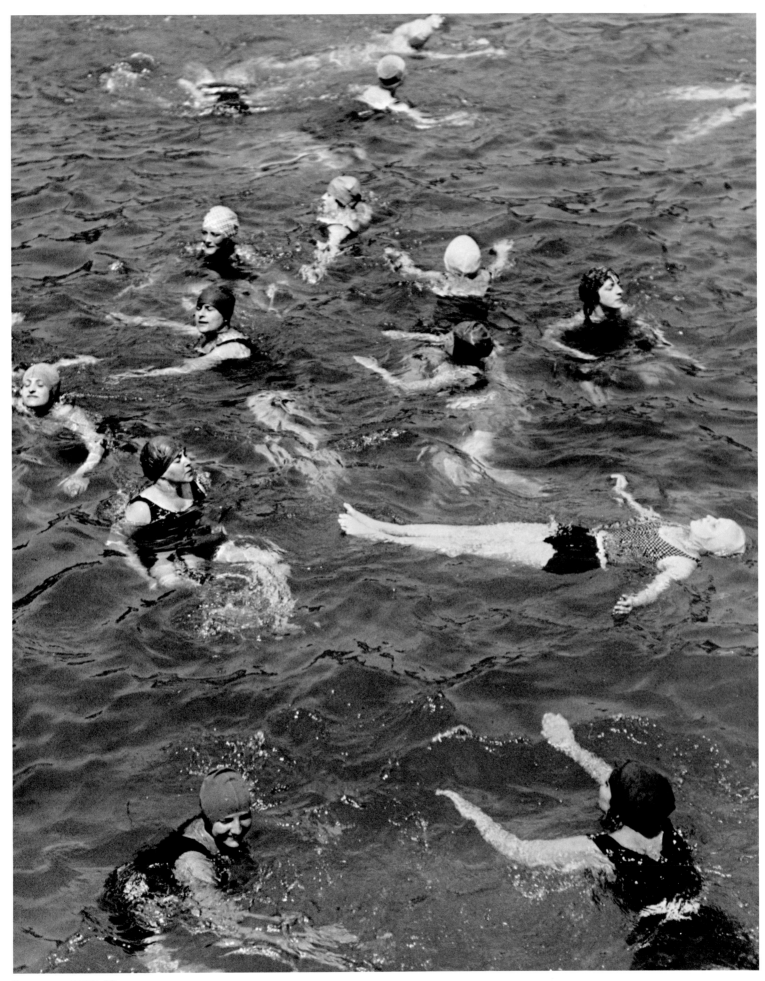

Europe, c. 1922–33

Harper's Bazaar,
July 1935

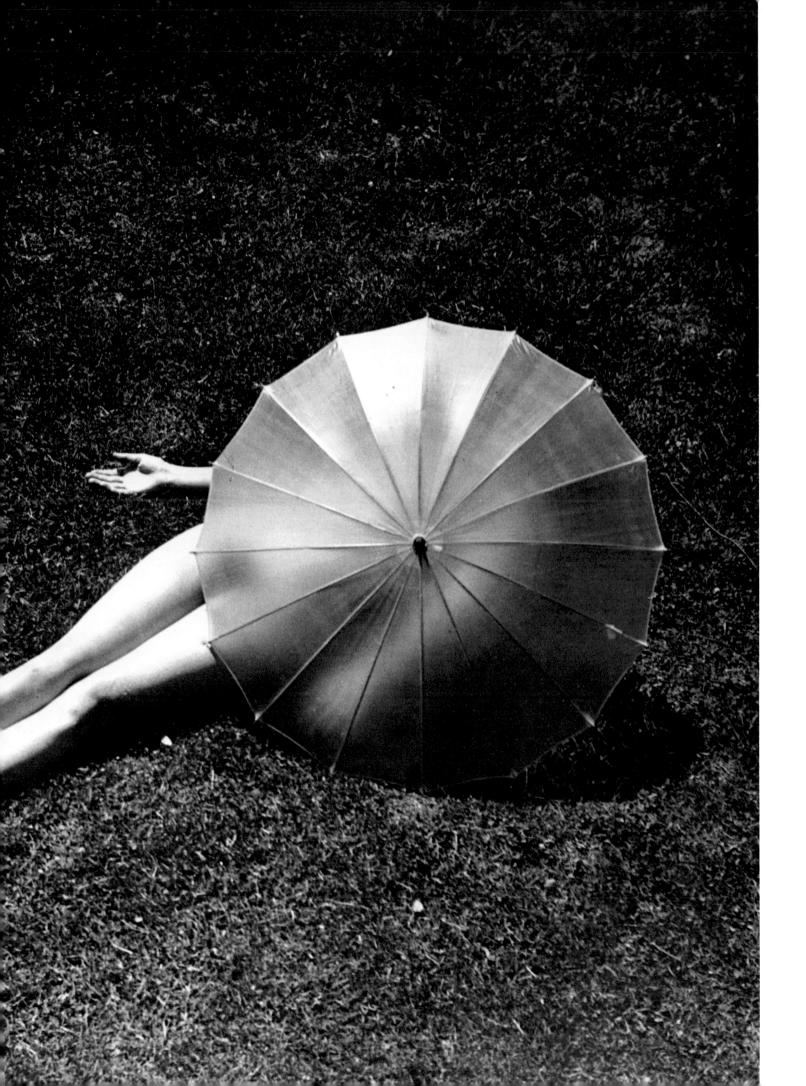

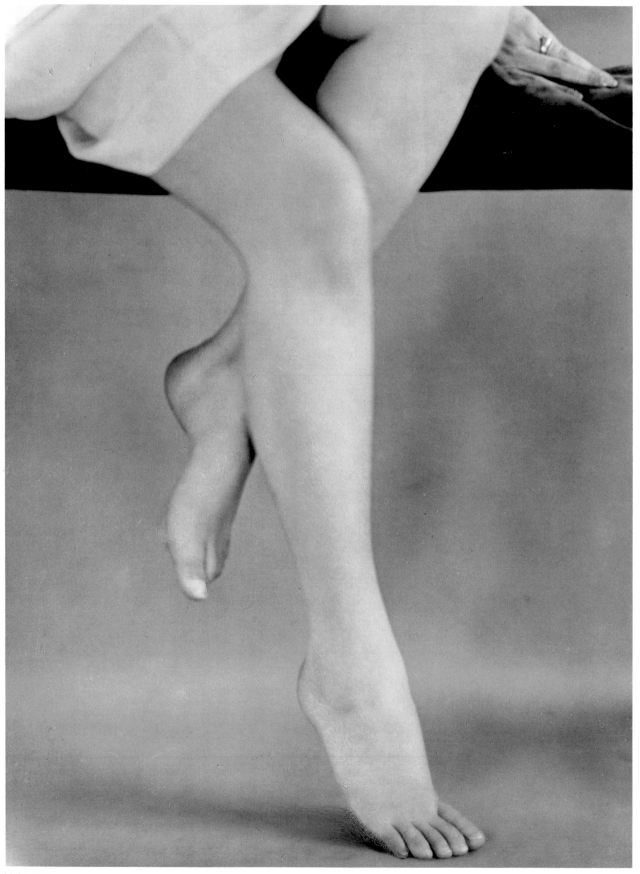

Unknown

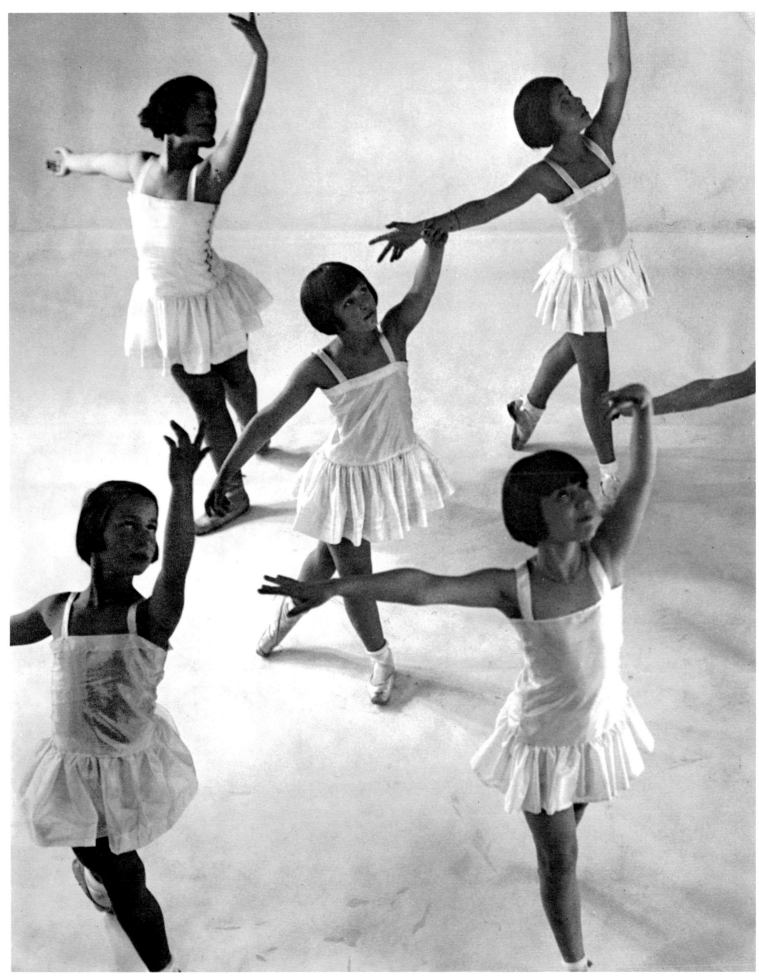

Berlin, c. 1927–34

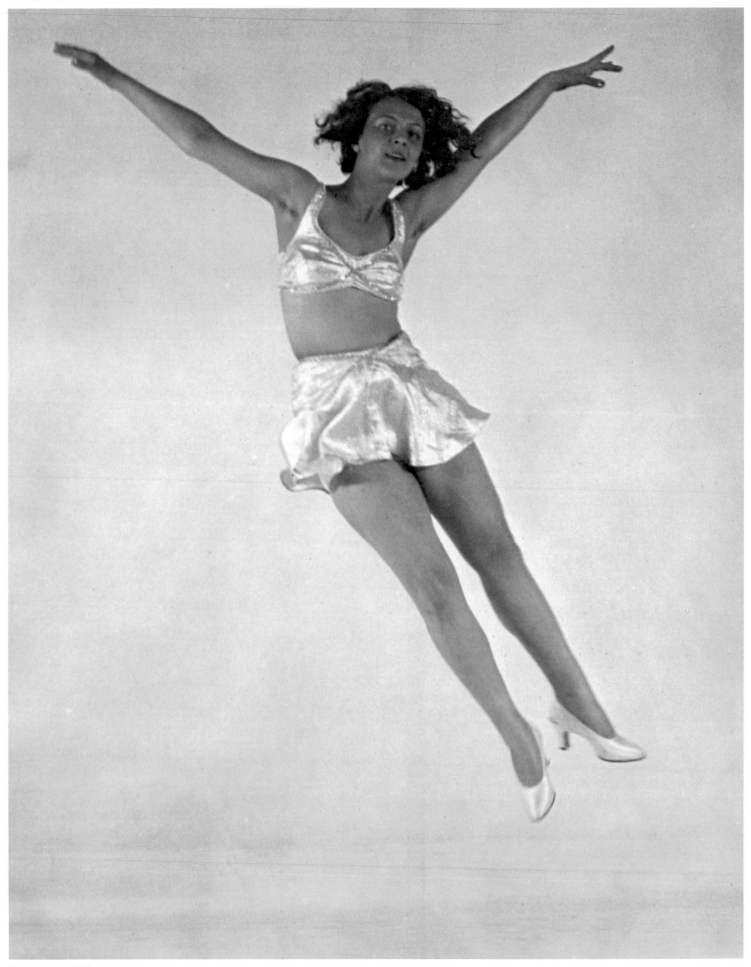

Europe, c. 1930

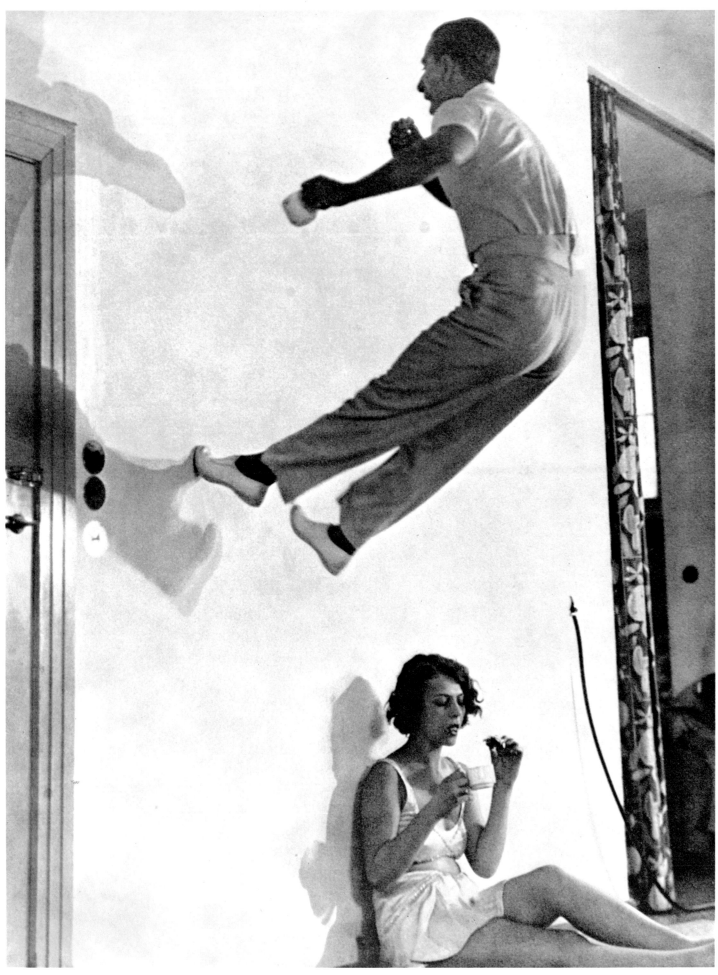

"Having Fun at Breakfast," Berlin, c. 1933

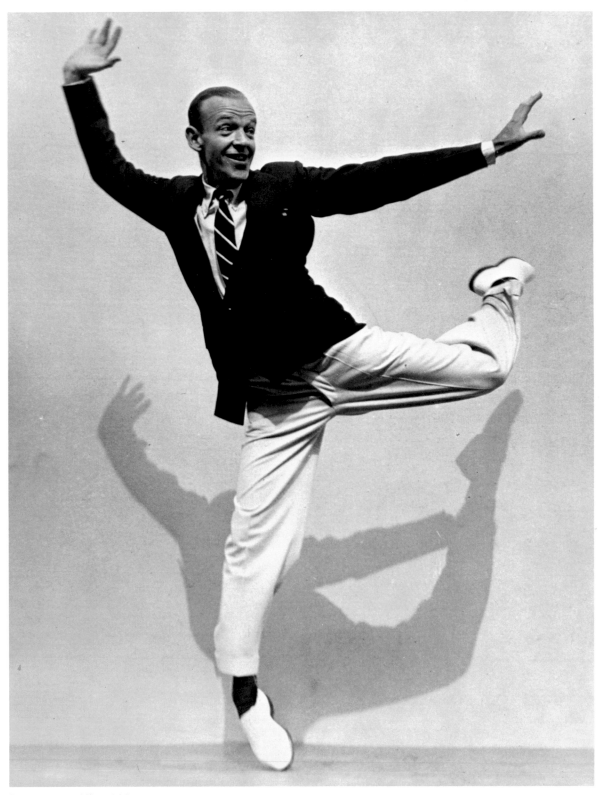

Fred Astaire, *Life* 1936

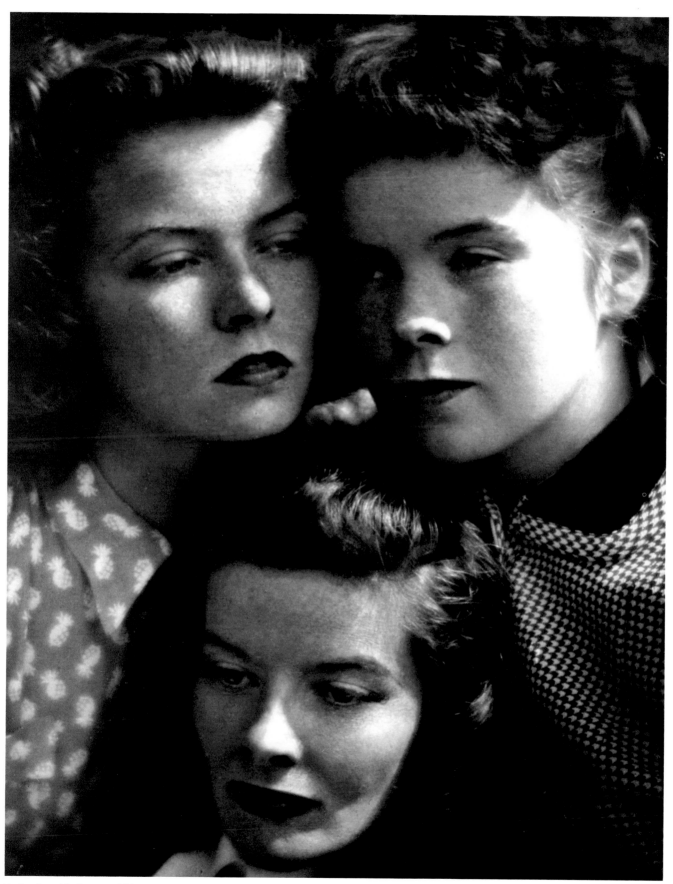

Katharine, Marion, and Margaret Hepburn, *Harper's Bazaar*, August 1939

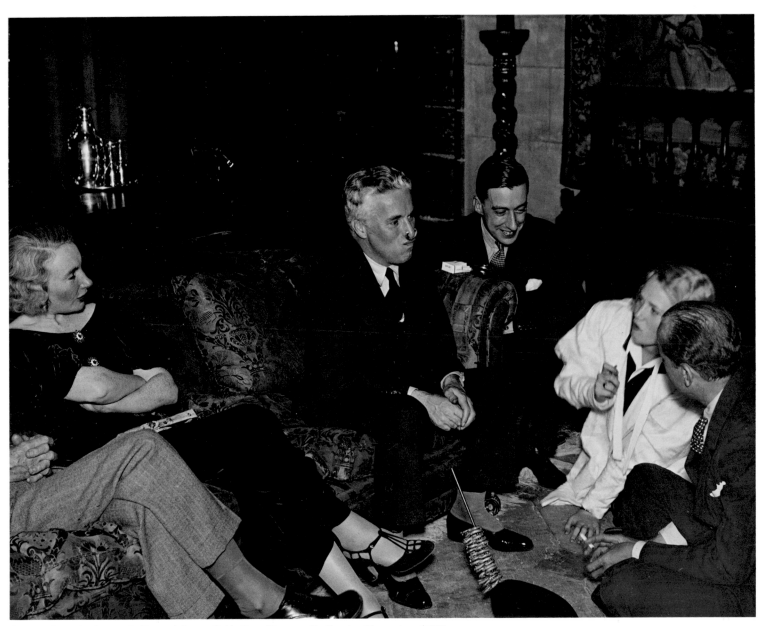

Charlie Chaplin (center), Carmel Snow (left), San Simeon, California, November 1933

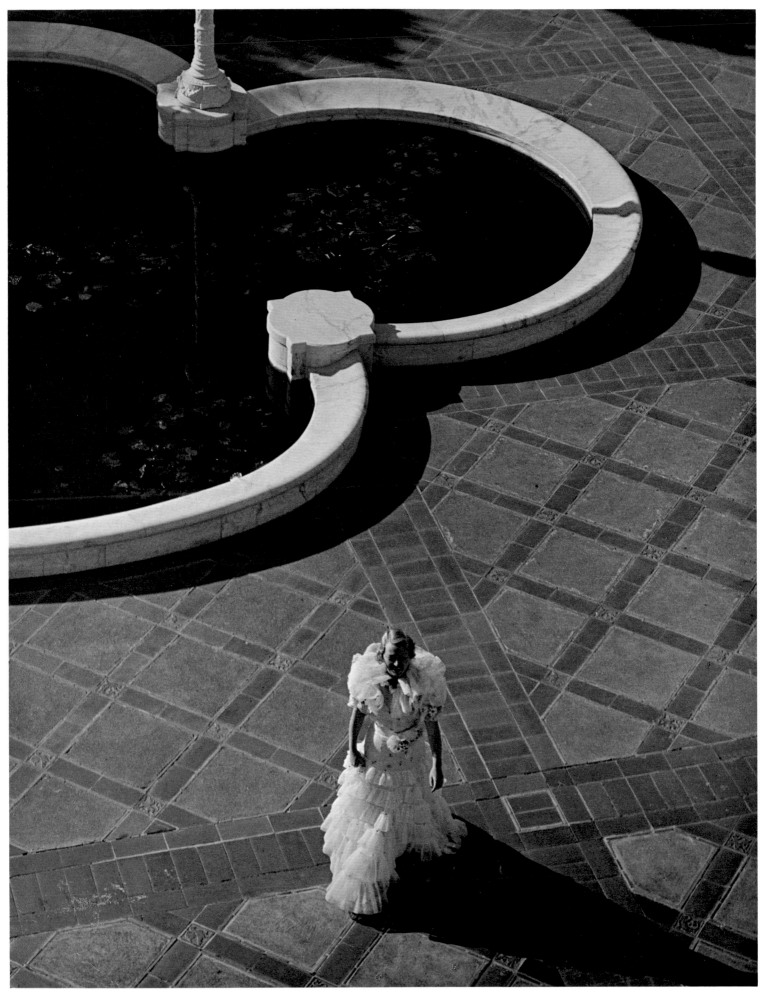

"Marion Davies, San Simeon, California," *Harper's Bazaar*, February 1934

Thornton Wilder, date unknown

Eleanor Roosevelt at Milgrim's, a famous specialty store. *Harper's Bazaar*, June 1941

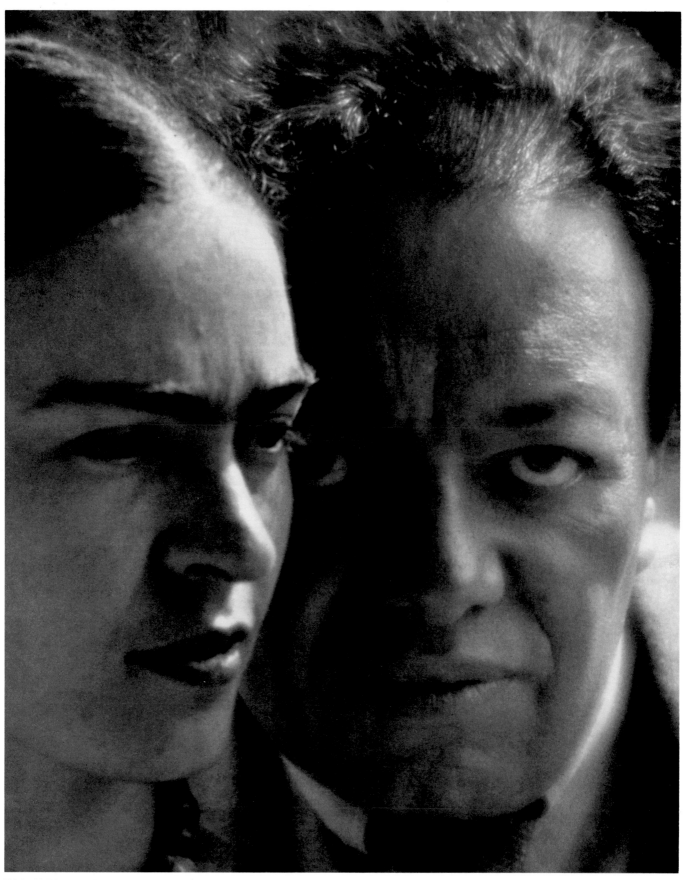

Frida Kahlo and Diego Rivera, Mexico, 1934

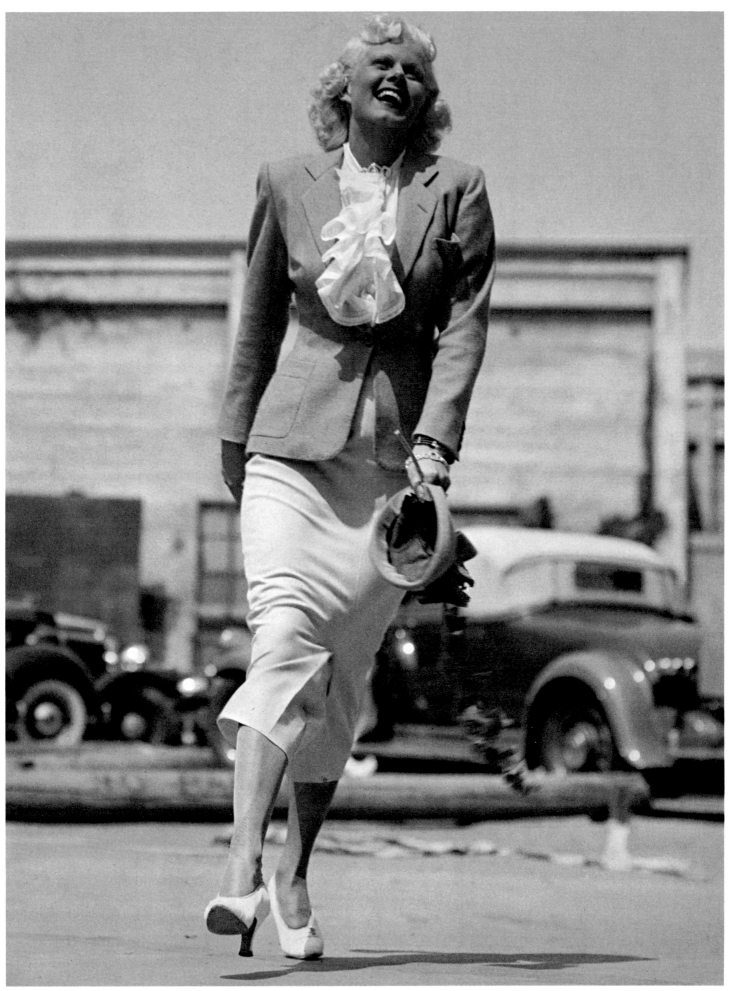

Jean Harlow, date unknown

"In 1932 I saw a photograph by Martin Munkacsi of three black children running into the sea, and I must say that it is that very photograph which was for me the spark that set fire to the fireworks . . . and made me suddenly realize that photography could reach eternity through the moment. It is only that one photograph which influenced me. There is in that image such intensity, spontaneity, such a joy of life, such a prodigy, that I am still dazzled by it even today."

Henri Cartier-Bresson

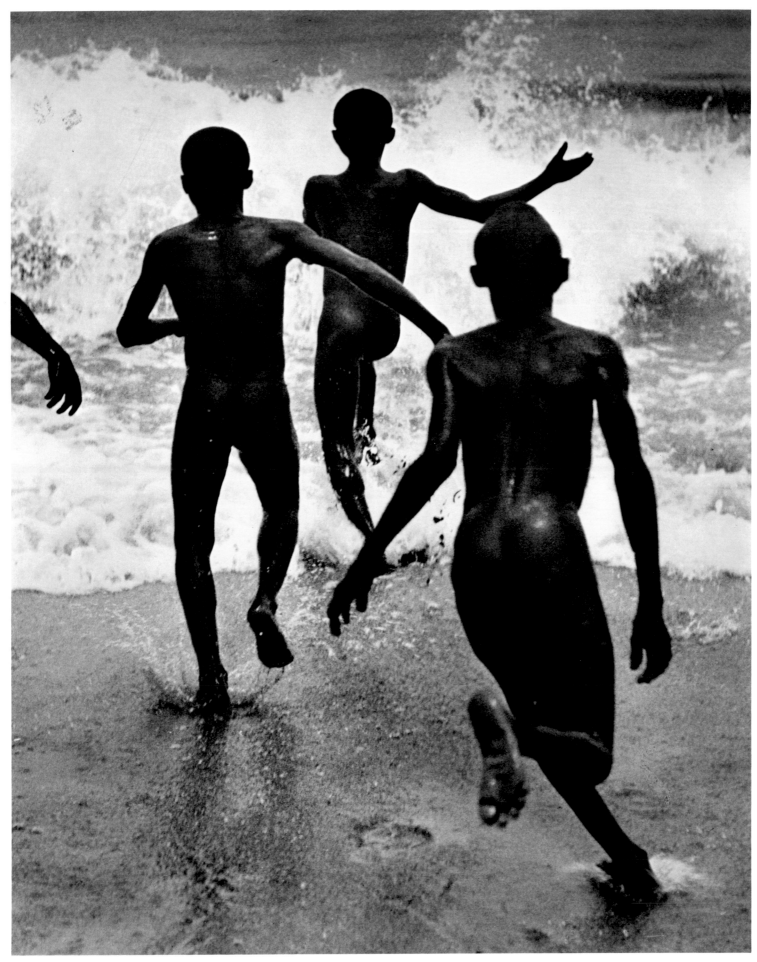

"Liberia, c. 1930," *Das Deutsche Lichtbild*, 1932

CHRONOLOGY

1896 Born on May 18 in the town of Kolozsvár, Hungary, near city of Munkács. (now Cluj Napoca, Romania).

1902 Family moves to Dicsö-Szent-Marton, Hungary (now Tirnavani, Romania), and changes its name from Mermelstein or Marmorstein to Munkácsi.

1912 Leaves for Budapest.

1914 Reports and writes poetry for sports paper *Az Est* and newspapers *Pesti Napló* and *Színházi Élet*.

1921–22 Begins to take sports photographs for *Az Est* and work for a theater magazine in Budapest.

1927–28 Leaves Budapest and moves to Berlin. Accepts three-year contract with Ullstein Verlag. Works primarily for *Berliner Illustrirte Zeitung* and contributes to other Ullstein magazines (*Die Dame*, *Koralle*, *Uhu*), and to *Die Woche* and *Studio* magazine.

1930–34 Freelance photographer, working for *The Studio*, and photographic yearbooks *Das Deutsche Lichtbild*, *Photographie* (France) and *Modern Photography* (England).

1933 His first fashion photographs appear in the December 1933 "Palm Beach" issue of *Harper's Bazaar*.

1934 Emigrates to New York and accepts a contract with *Harper's Bazaar*. Works with editor Carmel Snow and art director Alexey Brodovitch.

1934–46 Works for *Good Housekeeping*, *Ladies' Home Journal*, *Life*, *Pictorial Review* and *Town and Country*.

1943 After serious heart attack, he curtails most photography. While recovering, he devotes most of his energy to writing.

1945 *Fool's Apprentice*, a semi-autobiographical novel, is published.

1946 Works freelance for large corporations, including Ford and Reynolds. He also becomes a film cameraman and lighting designer.

1951 *Nudes* is published, with cover designed by Alexey Brodovitch.

1954 Works on film scripts and story outlines. Cameraman and lighting designer for the animated puppet film *Hansel and Gretel*. Writes and directs *Bob's Declaration of Independence*.

1963 Suffers heart attack at soccer game and dies July 14.

This chronology was compiled primarily from information from Joan Munkacsi; *Munkacsi: Spontaneity and Style*, exhibition catalog for the International Center of Photography, by Colin Osman, New York, 1978; and *Encylopédie Internationale des photographes de 1839 à nos jours*, Editions Camera Obscura, Geneva, 1985.

EXHIBITIONS

1935 XXIXth Salon, S.F.P., Paris.

1937 *Photography 1839–1937*, Museum of Modern Art, New York.

1940 *Tudor City Artists and Photographers*, New York.

1965 *Glamour Portraits*, Museum of Modern Art, New York.
 "The Photo Essay," Museum of Modern Art, New York.

1975 *Fashion Photography: Six Decades*, Emily Lowe Gallery, Hofstra University, Hempstead, New York, and Kornblee Gallery, New York.
 Fashion 1900–1939, Victoria & Albert Museum, London.

1977 *The History of Fashion Photography*, International Museum of Photography, Rochester, New York.

1978 *Spontaneity and Style: Munkacsi, a Retrospective*, International Center of Photography, New York.

1979 *Life: The First Decade*, Grey Art Gallery, New York University, New York.
 Fleeting Gestures: Dance Photographs, International Center of Photography, New York.

1979 *Martin Munkacsi*, Daniel Wolff, Inc., New York.

1980 *Avant-Garde Photography in Germany 1919–1939*, San Francisco Museum of Modern Art, San Francisco.

1982 *Lichtbildnisse: Das Porträt in der Fotografie*, Rheinisches Landesmuseum, Bonn.

1985 *Martin Munkacsi*, Photofind Gallery, Woodstock, New York.
 Shots of Style, Victoria and Albert Museum, London.
 "Self-Portrait: The Photographer's Persona 1840–1985," Museum of Modern Art, New York.

1989 *The New Vision: Photography Between the Wars*, Metropolitan Museum of Art, New York.

1990 *German Photography*, Metropolitan Museum of Art.
 Festival International de la Photo de Mode, Ethnography Museum, Budapest, Hungary.

1992 *Martin Munkacsi 1896–1963*, Picto-Bastille Gallery, Paris.
 Martin Munkacsi Photographies 1920–1961: Du Pictorialisme à la Photographie Contemporaine, Fnac Etoile Gallery, Paris.

COLLECTIONS

Joan Munkacsi, Woodstock, New York.

J. Paul Getty Museum, Malibu, California.

Jessica Brackman, FPG International, New York.

Museum of Modern Art, New York.

Metropolitan Museum of Art, New York.

International Center of Photography, New York.

International Museum of Photography, George Eastman House, Rochester, New York.

San Francisco Museum of Modern Art.

Museum Ludwig, Cologne.

F. C. Gundlach, Hamburg.

Gibbs Art Gallery, Charleston, South Carolina.

"Greater New York," Long Island City, c. 1940

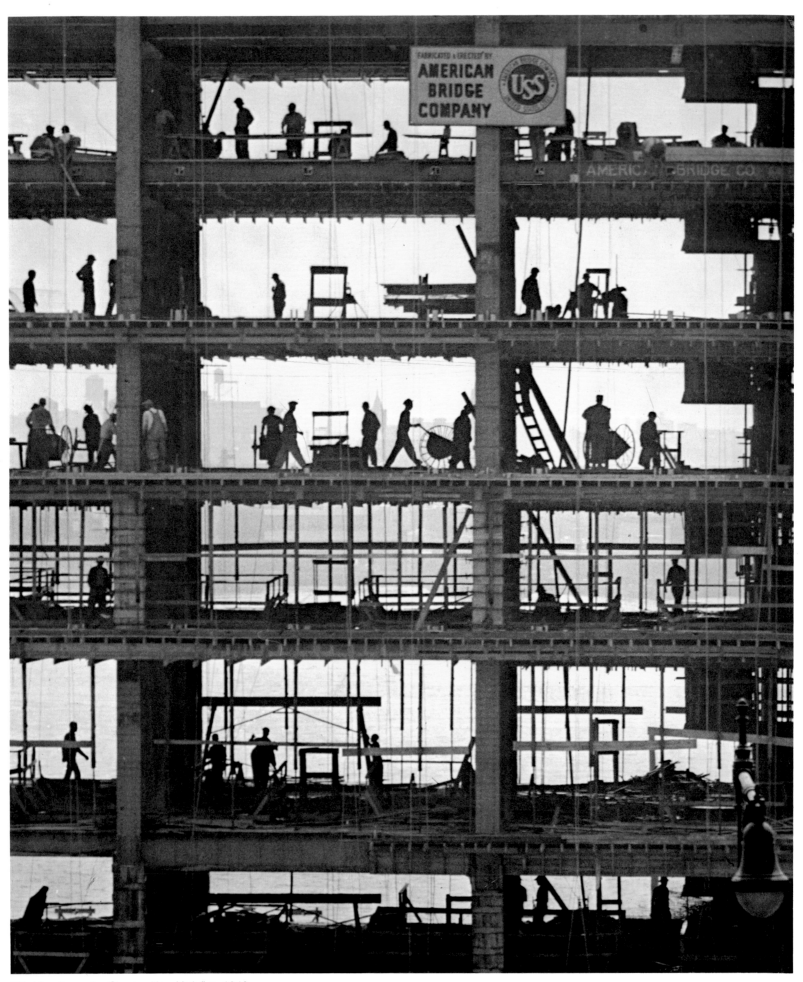

"Working toward a Greater New York," c. 1940

BIBLIOGRAPHY

Books

Beaton, Cecil, and Diane Buckland. *The Magic Image*. Boston: Little, Brown and Co., 1975.

Coke, Van Deren, Ute Eskildsen and Bernd Lohse. *Avant-Garde Photography in Germany 1919–1939*. Exhibition catalog, San Francisco Museum of Modern Art: San Francisco, 1980.

Encyclopédie Internationale des photographes de 1839 à nos jours. Geneva: Editions Camera Obscura, 1985.

Gernsheim, Helmut, Renate and L. Fritz Gruber. *The Imaginary Photo Museum*. Cologne, 1981; New York: Crown, 1982.

Gidal, Tim N., ed. *Deutschland: Beginn des Modernen Photojournalismus*. Lucerne and Frankfurt, 1972.

Gruber, Fritz L., ed. *Beauty: Variations on the Theme of Woman by Masters of the Camera—Past and Present*. London and New York, 1965.

Hall-Duncan, Nancy. *The History of Fashion Photography*. New York: Alpine, 1979; *Histoire de la photographie de mode*, Paris, 1979.

Hall-Duncan, Nancy. *The Beginnings of Realism in Fashion Photography*. Exhibition catalog, "The History of Fashion Photography," at the International Museum of Photography: Rochester, 1977.

Harrison, Martin. In *Shots of Style: Great Fashion Photographs Chosen by David Bailey*. London, 1985.

Hicks, Wilson. *Words and Pictures: An Introduction to Photojournalism*. New York, 1952.

Honnef, Klaus, ed. *Lichtbildnisse: Das Porträt in der Fotografie*. Cologne, 1982.

How America Lives. New York: Henry Holt, 1941.

Littman, Robert, Ralph Graves and Doris C. O'Neill. *Life: The First Decade 1936–45*. New York, 1979; London, 1980.

Lloyd, Valerie, and others. *Fashion 1900–1939*. Exhibition catalog. London, 1975.

Martin Munkacsi. Ilford '92 Calendar, 1992.

Mellor, David, ed. *Germany: The New Photography 1927–33*. London, 1978.

Munkacsi, Martin. *Fool's Apprentice*. New York: Reader's Press, 1945.

Munkacsi, Martin. *Nudes*. New York: Greenberg, 1951.

Munkacsi: Spontaneity and Style. Exhibition catalog for the International Center of Photography, with text by Colin Osman. New York, 1978.

Naylor, Colin, ed. *Contemporary Photographers*. London: St. James Press, 1988.

Snow, Carmel, with Mary Louise Aswell. *The World of Carmel Snow*. New York: McGraw-Hill, 1962.

The Studio. New York: Time-Life Books, 1971.

Sullivan, Constance (ed.) *Nude Photographs 1850–1980*. New York, 1980.

Syberberg, Hans-Jürgen, ed. *Fotografie der 30er Jahre: Eine Anthologie*. Munich, 1977.

Tausk, Petr. *Geschichte der Fotografie im 20. Jahrhundert/ Photography in the 20th Century*. Cologne, 1977; London, 1980.

Taylor, G. Herbert, ed. *My Best Photograph and Why*. New York: Dodge, 1937.

Thornton, Gene. *Fashion Photography*. Exhibition catalog, Emily Lowe Gallery, Hofstra University, Hempstead, New York: 1975.

White, Nancy, and John Esten. *Style in Motion: Munkacsi Photographs of the '20s '30s, and '40s*. New York: Clarkson N. Potter, 1979.

Articles

Althaus, P. F. "Glamour Portraits." *Camera* (Lucerne), November, 1965.

"Art in the Camera." *This Week*, March 7, 1948.

Avedon, Richard. "Munkacsi." *Harper's Bazaar*, June, 1964.

Avedon, Richard. "Munkacsi." *Harper's Bazaar: 100 Years of the American Female*, reprint, June, 1967.

Clary, Max. "Un Eugène Carrière de la photographie: Munkacsi." *Le Miroir du Monde*, October 28, 1933.

Edwards, Owen. "Blow-Out: The Decline and Fall of the Fashion Photographer." *New York*, May 28, 1967.

Edwards, Owen. "From Rags to Photographic Riches." *New York Times Magazine*, November 6, 1977.

Gautrand, J. C. "Munkacsi, l'hymne à la vie." *Photographies*, December, 1990.

Hackett, Gabriel P. "Martin Munkacsi." *Infinity*, September, 1963.

Hall, Jane. "Sunrise Over Newark." *The Saturday Evening Post*, October 9, 1937.

Ház, Nicholas. "Martin Munkacsi." *Camera Craft*, July, 1935.

Ház, Nicholas. "Pictorial Analysis." *The Camera*, October, 1935.

Hoghe, Raimund, essay in *Retrospektive Fotografie: Munkacsi*. Bielfeld and Dusseldorf, 1980.

Horvat, Frank. "My Father—Martin Munkacsi: Interview with Joan Munkacsi." *Photographers International*, June, 1992.

"How America Lives." *U.S. Camera*, May, 1942.

Knipsen. Berlin: Ullstein Verlag, 1929.

"L'Eternel Munkacsi." *Photo* (Paris), October, 1978.

Lohse, Bernd. "Photo-Journalism, The Legendary Twenties." *Camera* (Lucerne), April, 1967.

Malcolm, Janet. "Photography." *The New Yorker*, September 22, 1975.

Marks, Robert W. "Portrait of Munkacsi." *Coronet*, January, 1940.

Munkacsi, Martin. "Light Up Your Darkroom." New York, Universal Photo Album, 1951.

Munkacsi, Martin. "Must They Be Sharp?" *Photography*, Fall, 1947.

Munkacsi, Martin. "Think While You Shoot." New York, *Harper's Bazaar*, November, 1935

Osman, Colin. "Munkacsi." *Creative Camera Yearbook 1977*, London, 1976.

Popular Photography, November, 1963.

Time-Life editors. "Making Fashion Come Alive." *Photography Year 1979*, New York, 1979.

Acknowledgments

We would like to thank Joan Munkacsi for her support and guidance, and the following people for their assistance and advice: Jessica Brackman at FPG International, New York; Helen Munkacsi Sinclair; Marjorie Miller at the Fashion Institute of Technology, New York; Pierre Gassmann of Picto, Paris; Cory Gooch and Teruko L. Burrell at the J. Paul Getty Museum, Malibu, California; Howard Greenberg of Howard Greenberg Gallery, New York; F.C. Gundlach of P. P. S. Gallerie, Hamburg, Germany; Miles Barth of the International Center of Photography, New York; Martha Lazar; and Eileen Travell at the Metropolitan Museum of Art, New York.

Credits

Note: Unless otherwise noted, all works are courtesy of, and copyright by, the Estate of Martin Munkacsi.

Pages 18, 20, 21, 25, 29, 33, 44, 45, reproduction courtesy of J. Paul Getty Museum, Malibu, California; pages 14, 16–17, 27, 40, 62, 63, 64, photographs courtesy of F. C. Gundlach, P. P. S. Gallerie, Hamburg, Germany; pages 18, 19, 25, 30, 31, 66, reproductions courtesy of the International Center of Photography, New York; pages 24, 26, 32, photographs courtesy of Jessica Brackman, FPG International, New York.

Library of Congress Catalog Card Number: 92-081617
ISBN: 0-89381-516-0

The staff at Aperture for
Martin Munkacsi: An Aperture Monograph is:
Michael E. Hoffman, Executive Director
Andrew Wilkes, Editor
Michael Sand, Managing Editor
James Anderson, Eve Morgenstern, Editorial Work-Scholars
Stevan Baron, Production Director
Sandra Greve, Production Associate

Book and jacket design by Wendy Byrne.
Composition by The Sarabande Press. Duotone separations by Robert Hennessey. Printed and bound by Everbest Printing Co., Ltd, Hong Kong.

Aperture publishes a periodical, books, and portfolios of fine photography to communicate with serious photographers and creative people everywhere. A complete catalog is available upon request. Address: 20 East 23rd Street, New York, New York 10010.

First edition

10 9 8 7 6 5 4 3 2 1